IMPRESSIONIST
COLORING BOOK

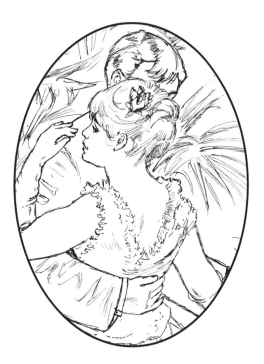

IMPRESSIONIST
COLORING BOOK

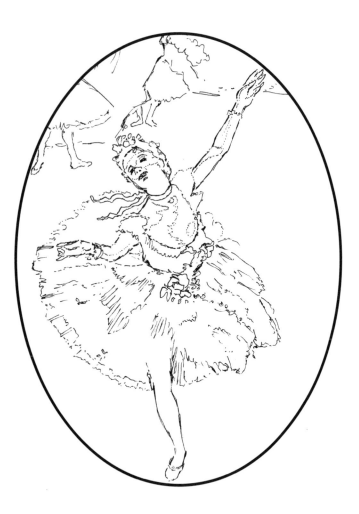

CHARTWELL
BOOKS

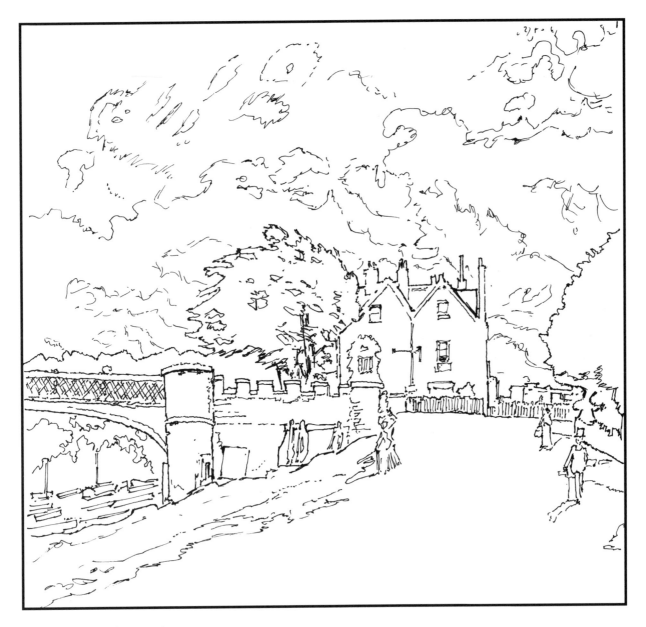

This edition printed in 2013 by
CHARTWELL BOOKS
an imprint of Book Sales
a division of Quarto Publishing Group USA Inc.
142 West 36th Street, 4th Floor
New York, New York 10018
USA

Copyright © Arcturus Holdings Limited
26/27 Bickels Yard, 151–153 Bermondsey Street,
London SE1 3HA

ISBN: 978-0-7858-3044-3
AD003564NT

Printed in China
Reprinted in 2015 (twice).

INTRODUCTION

Use the outlines in this book to produce your own impressionist artworks with colored pencils.

If you want to copy the original colors, you will need to find a color reproduction of the painting. You should be able to track one down in a book of impressionist artists or you may find a color postcard of the painting. If you prefer to use your own color scheme, try to give the picture either a harmonious or contrast-strong combination of colors.

Pencil color is not as intense as paint, so it really helps to add layers. When using darker shades, don't just apply one layer of color. Darker tones look better if you work over the same area several times to produce a greater intensity of color. For example, most black areas are either warm or cool in hue. To achieve this, apply a layer of black, and then add another layer of deep brown or dark blue on top. If you want to make the black even more intense, put blue over brown over black, or brown over blue over black. Then, for the really dense areas, add another layer of black.

When making blue or red, add layers of different blues and reds to increase the intensity. Sometimes the addition of purple can also give a blue or a dark red more power in the composition. Other times, your top layer can be put on quite lightly, just to change the quality of the color a little.

Try making the tonal marks of the pencils in different directions to build a more interesting texture, so that your picture looks more like a painting.

Happy coloring!

James Tissot
Le pont du HMS Calcutta (Portsmouth)
1876

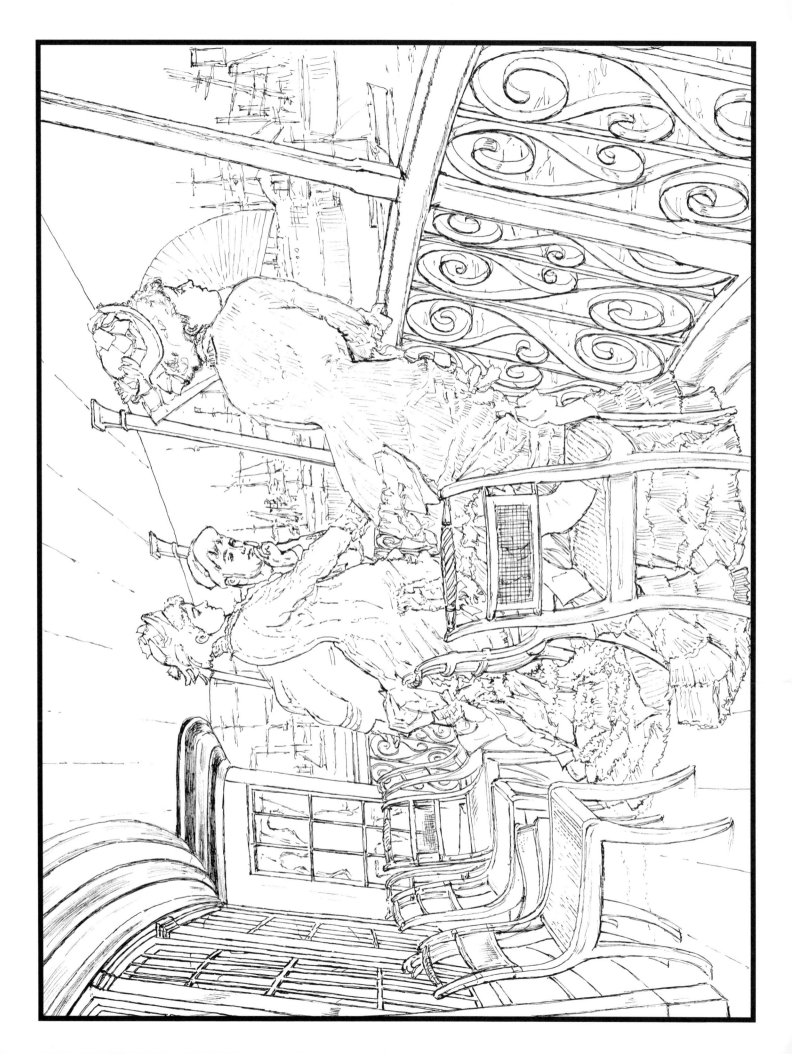

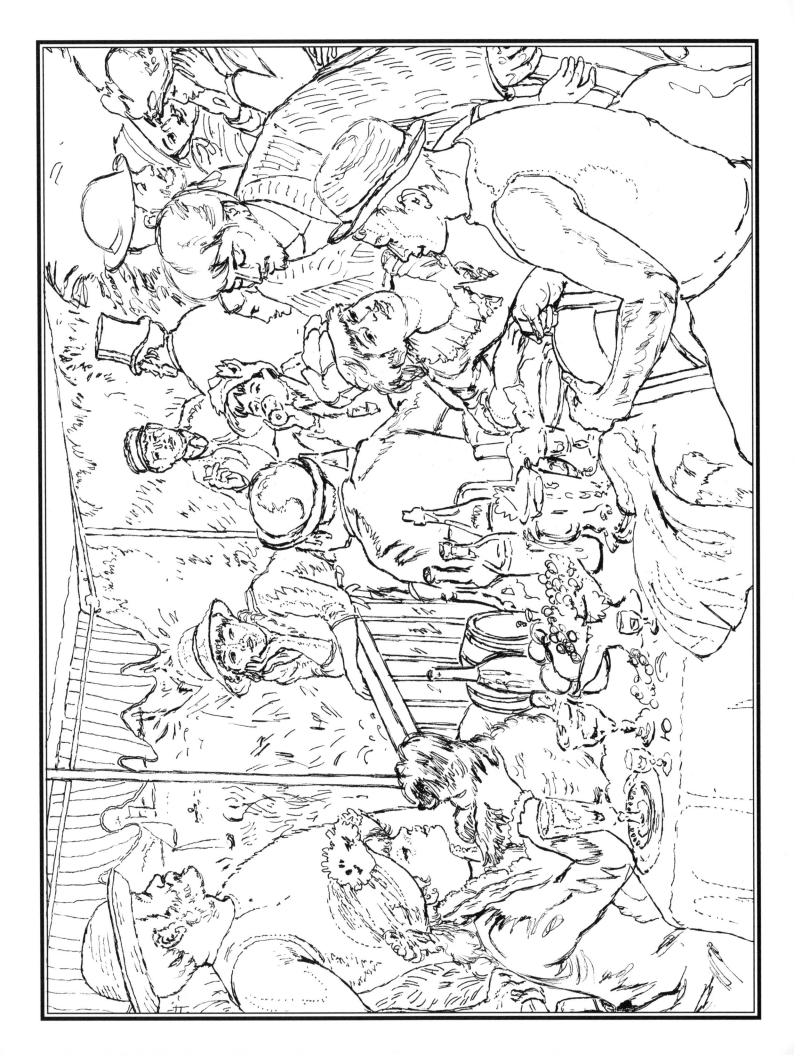

Pierre-Auguste Renoir
La balançoire
1876

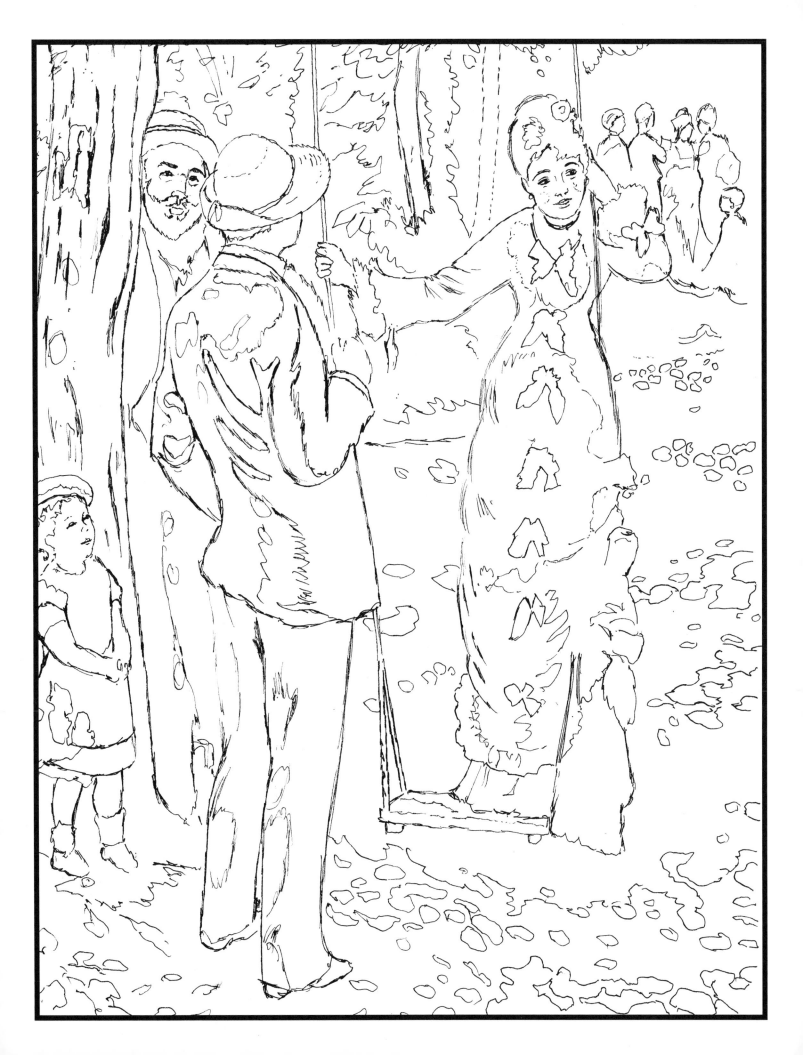

Pierre-Auguste Renoir
Les parapluies
1881-6

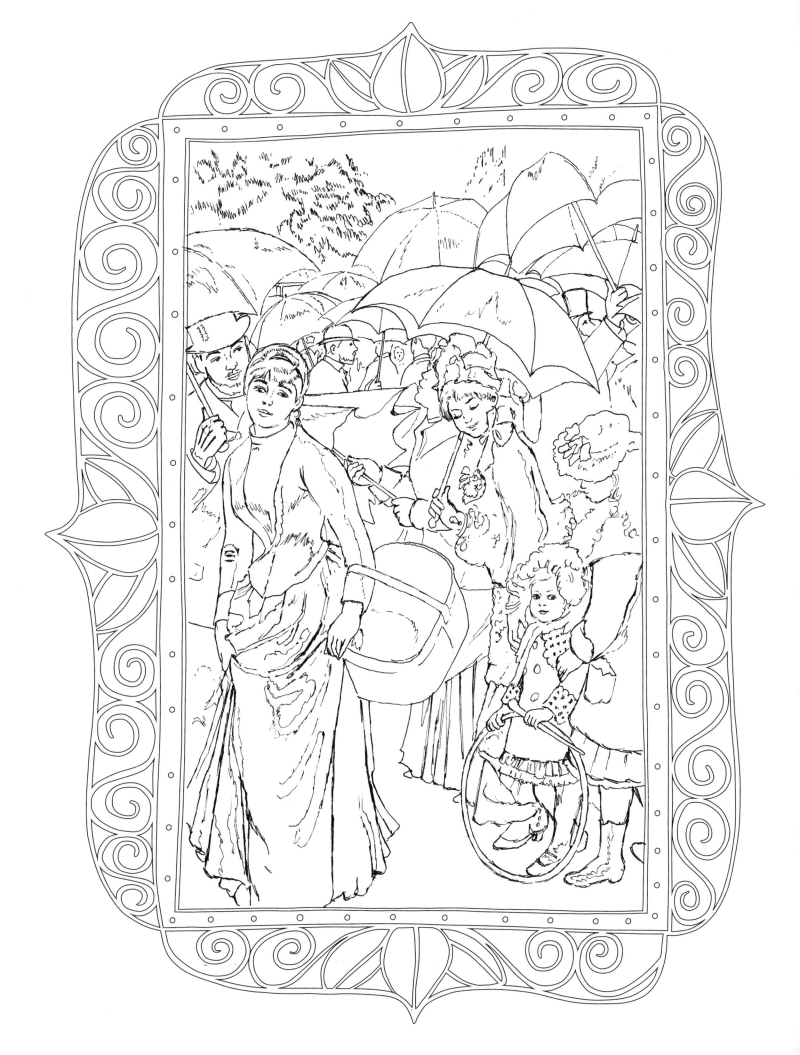

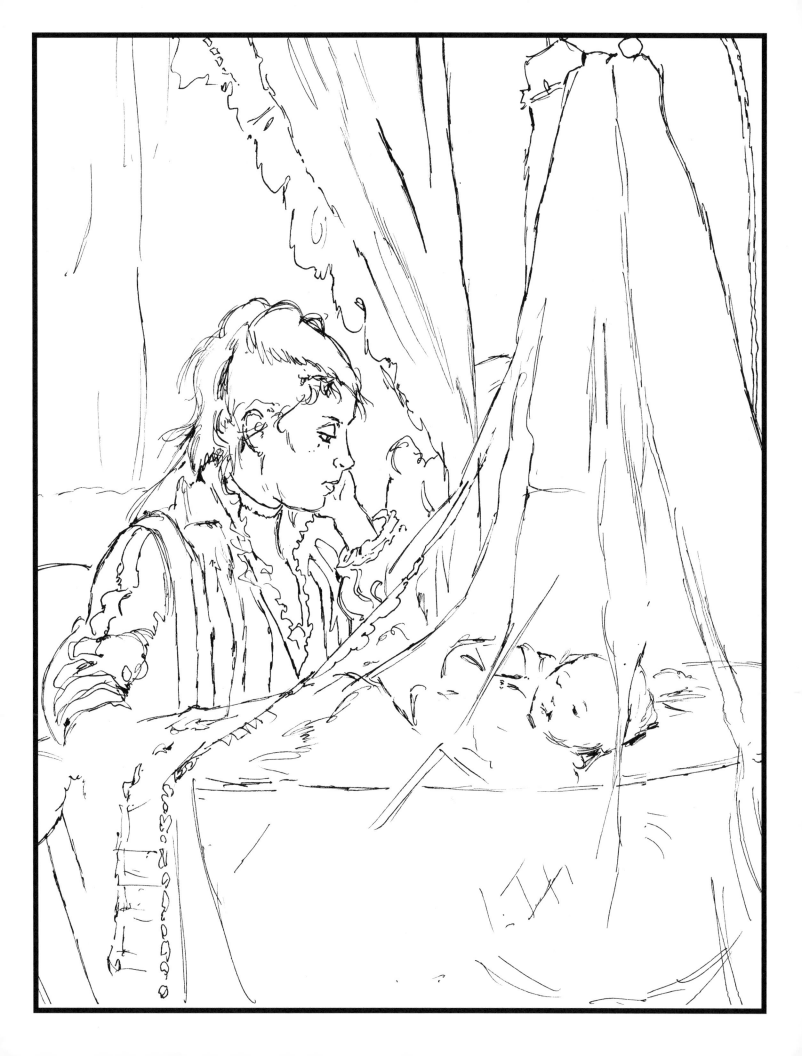

Camille Pissarro
Jeune fille à la baguette
1881

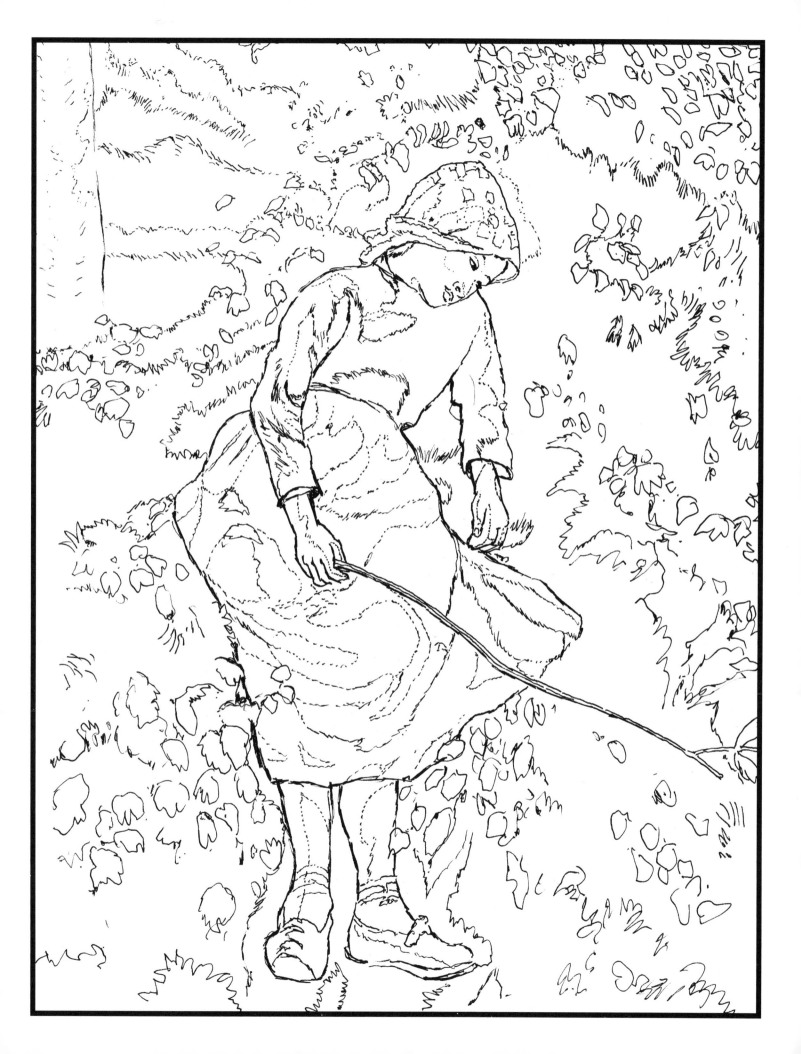

Claude Monet
Femmes au jardin
1866

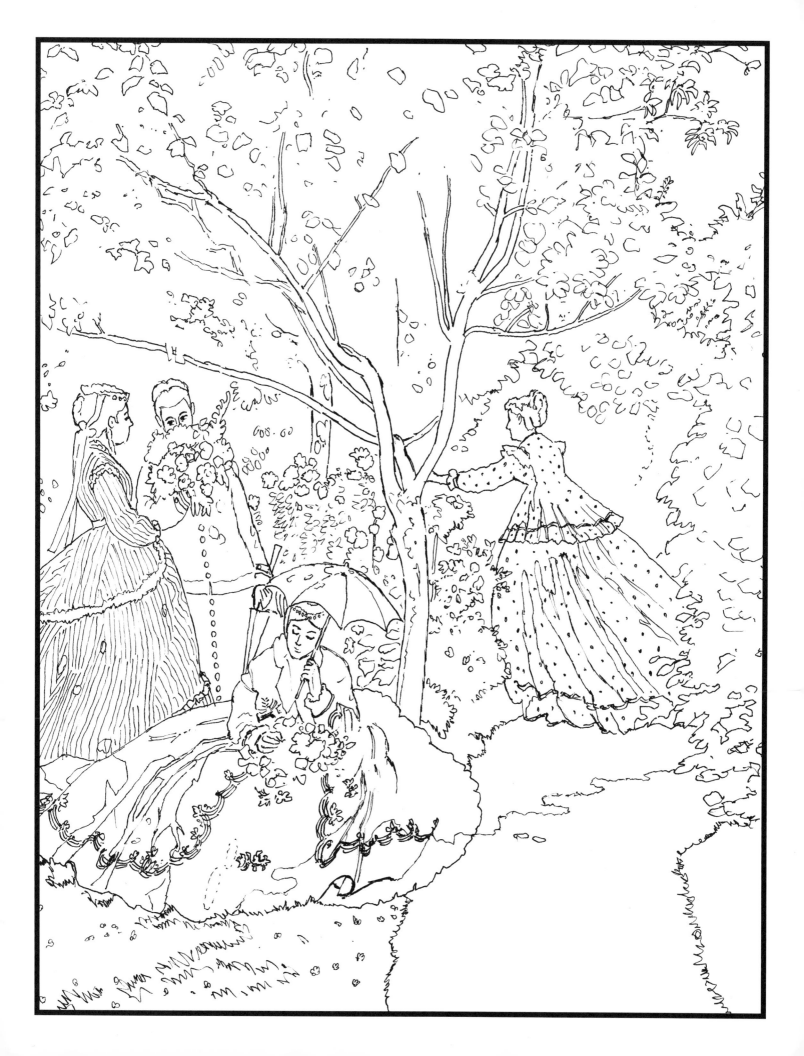

Edgar Degas
L'étoile [la danseuse sur la scène]
1878

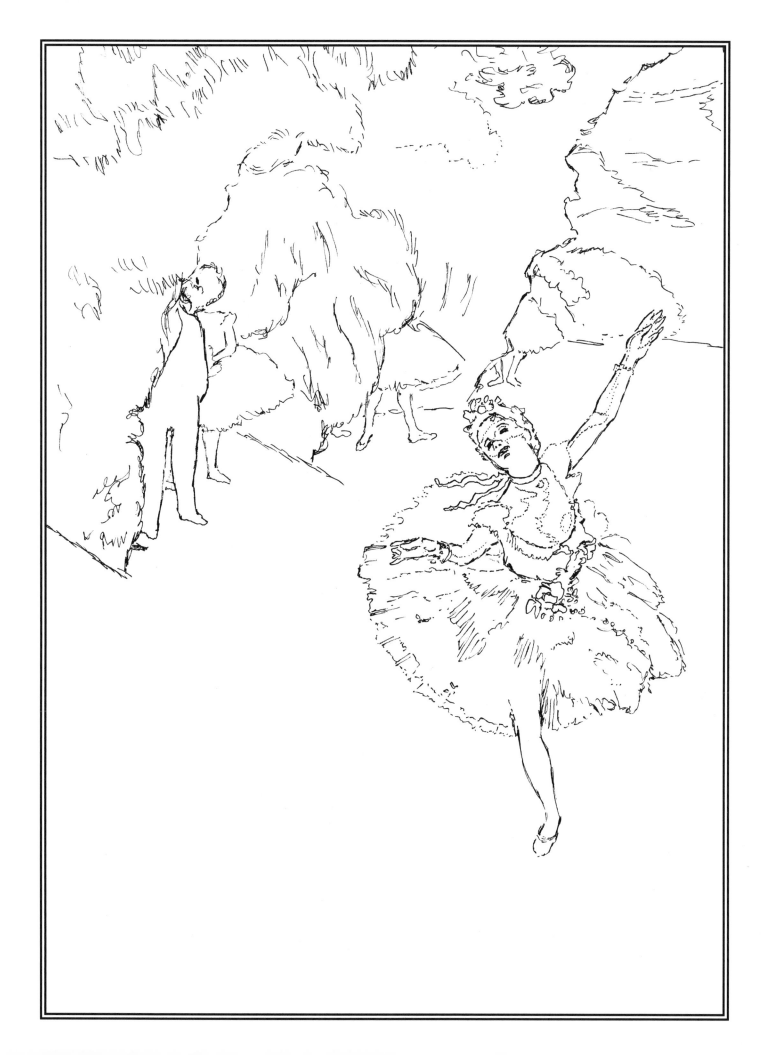

Edgar Degas
Monsieur et Madame Edmondo Morbilli
1865

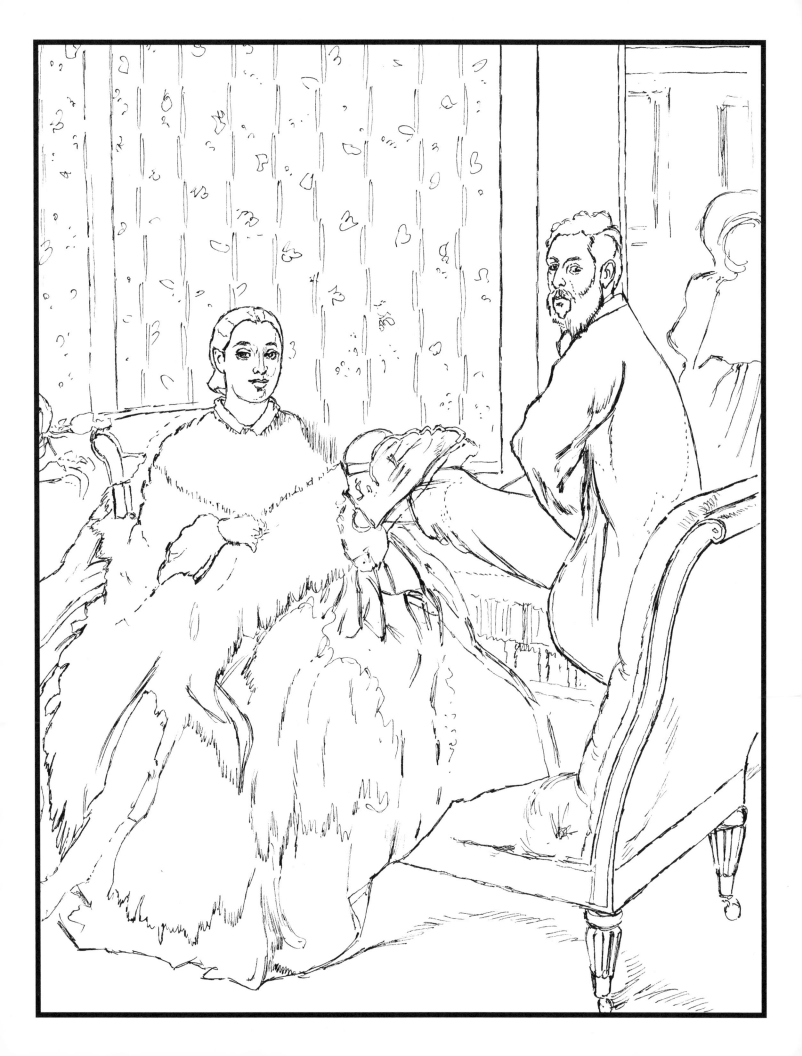

Edgar Degas
La salle de ballet de l'Opéra, rue Le Pelletier
1872

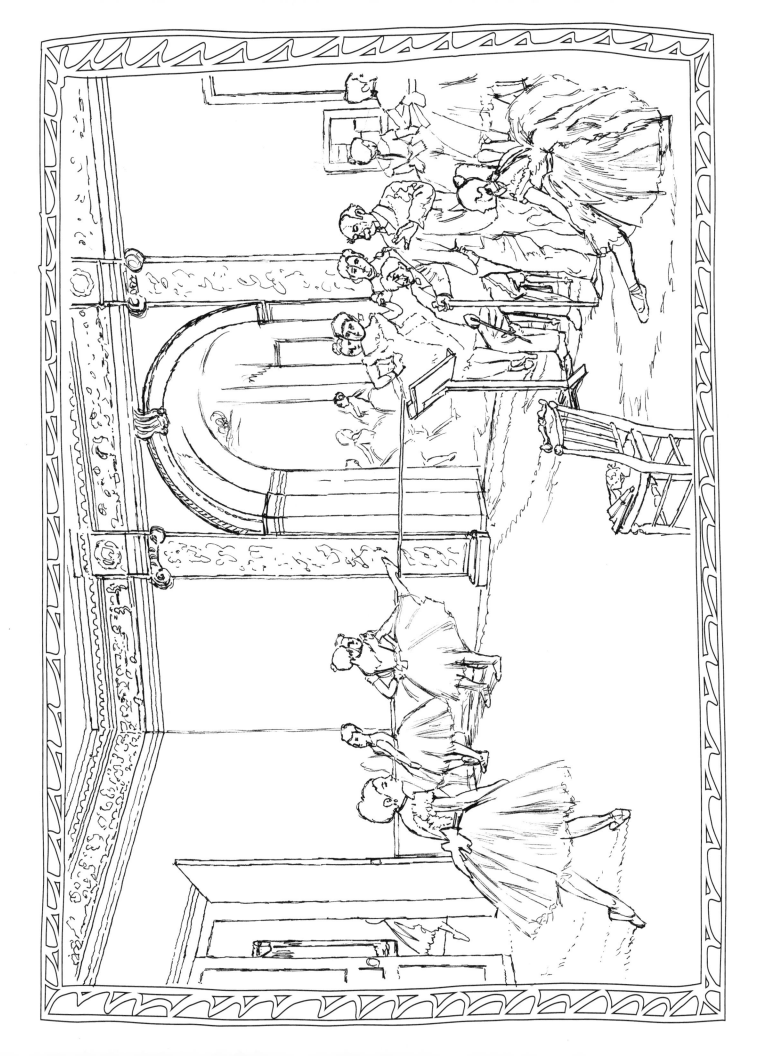

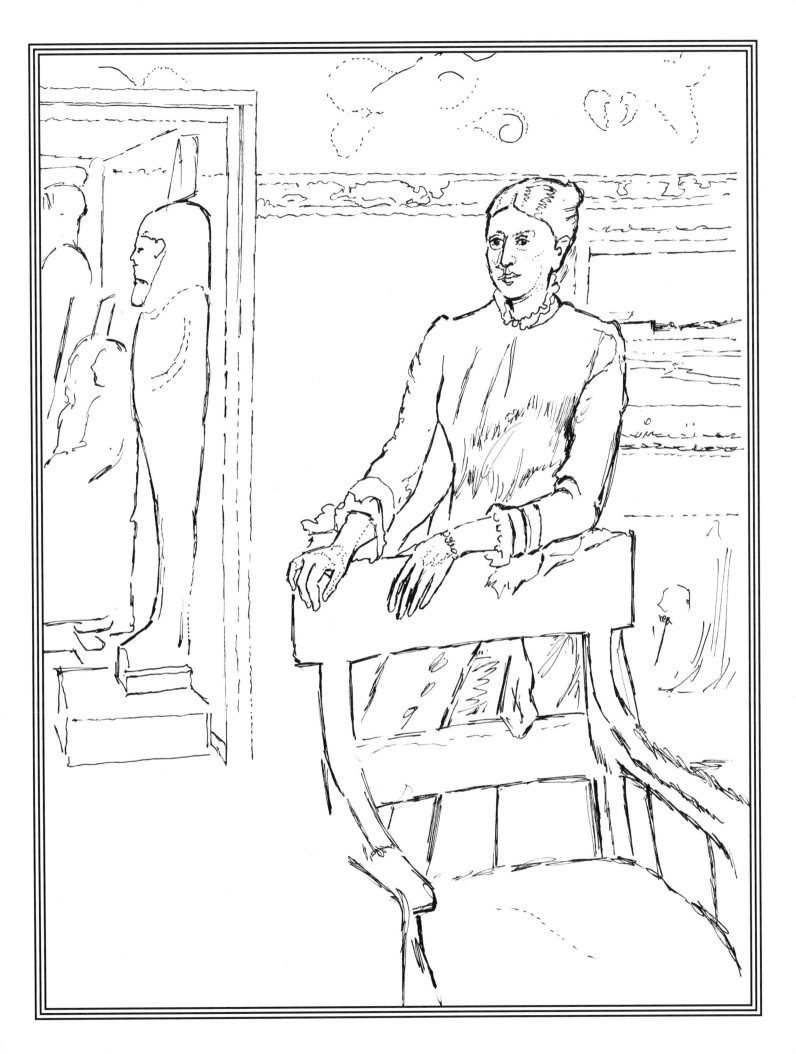

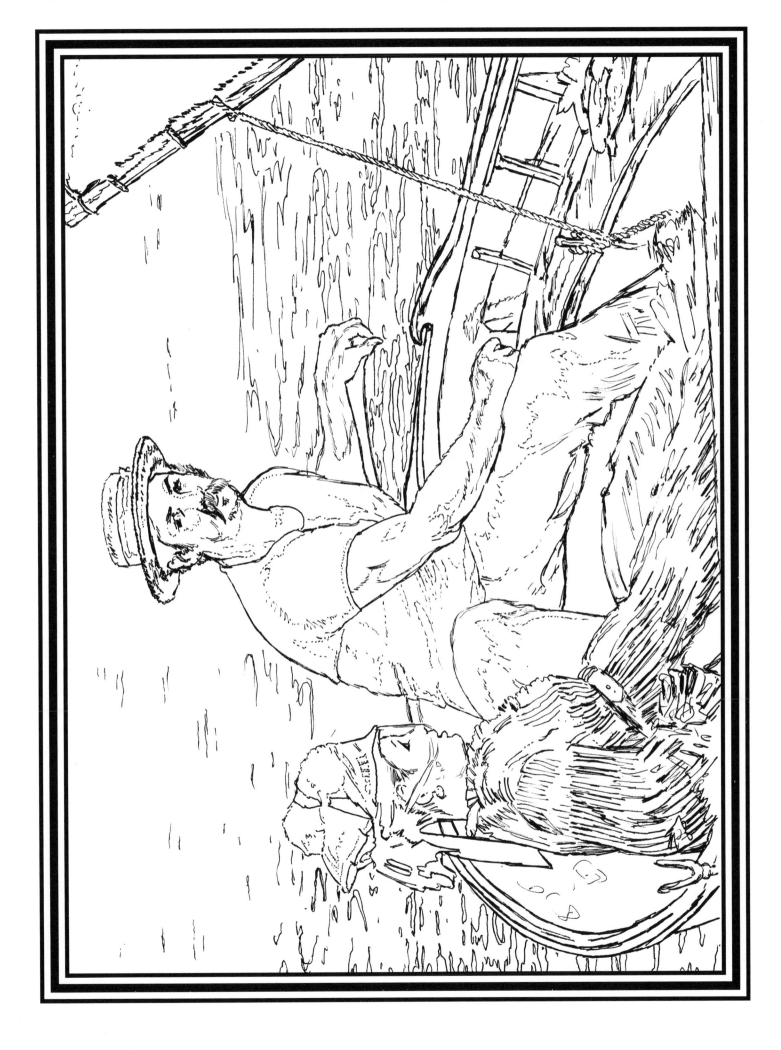

Édouard Manet
Lola de Valence
1862

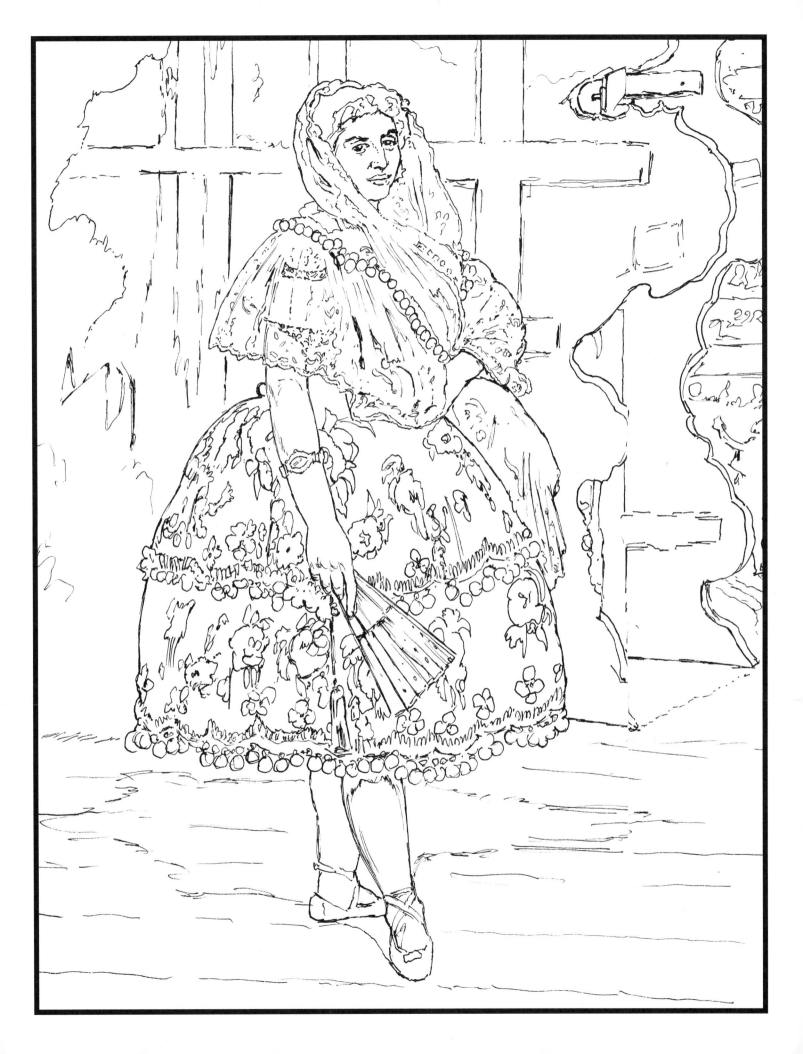

Édouard Manet
Berthe Morisot
1872

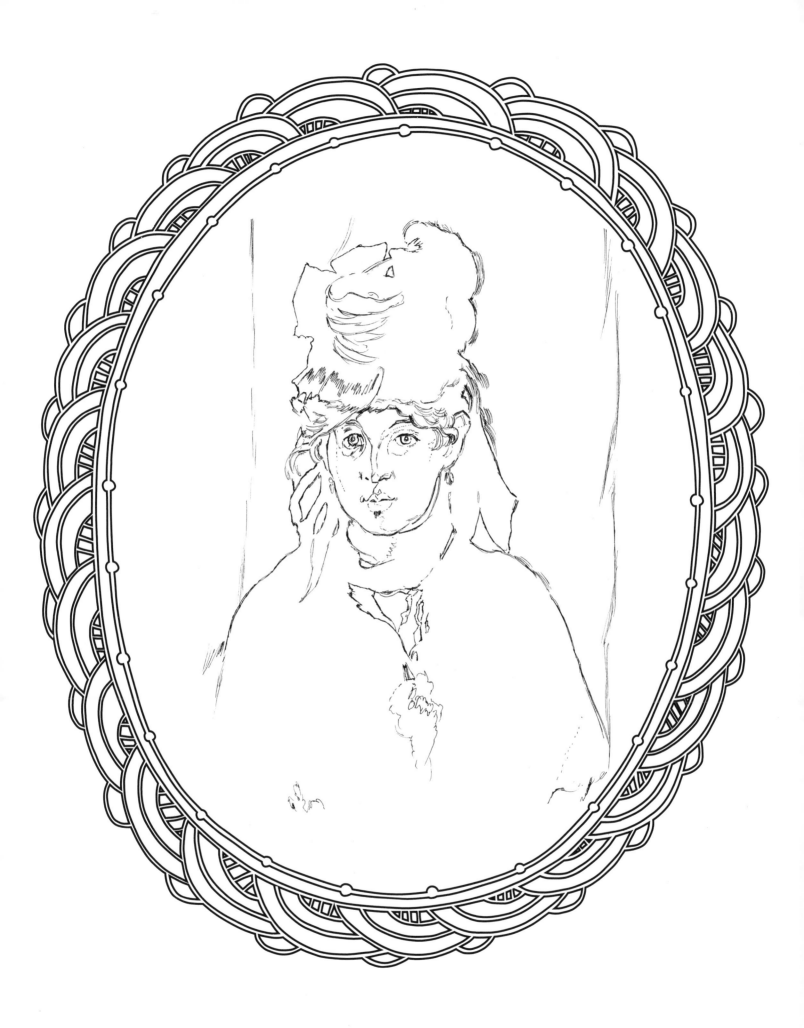

Édouard Manet
Le balcon
1868-9

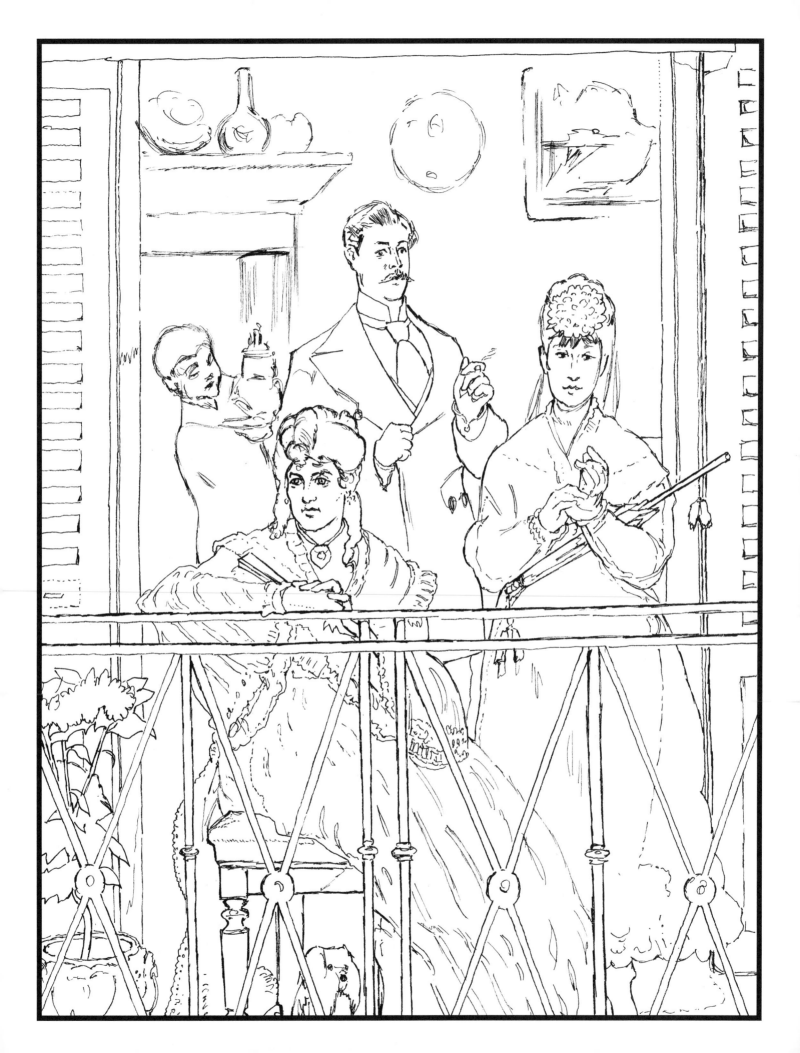

Édouard Manet
Le bar aux Folies-Bergère
1882

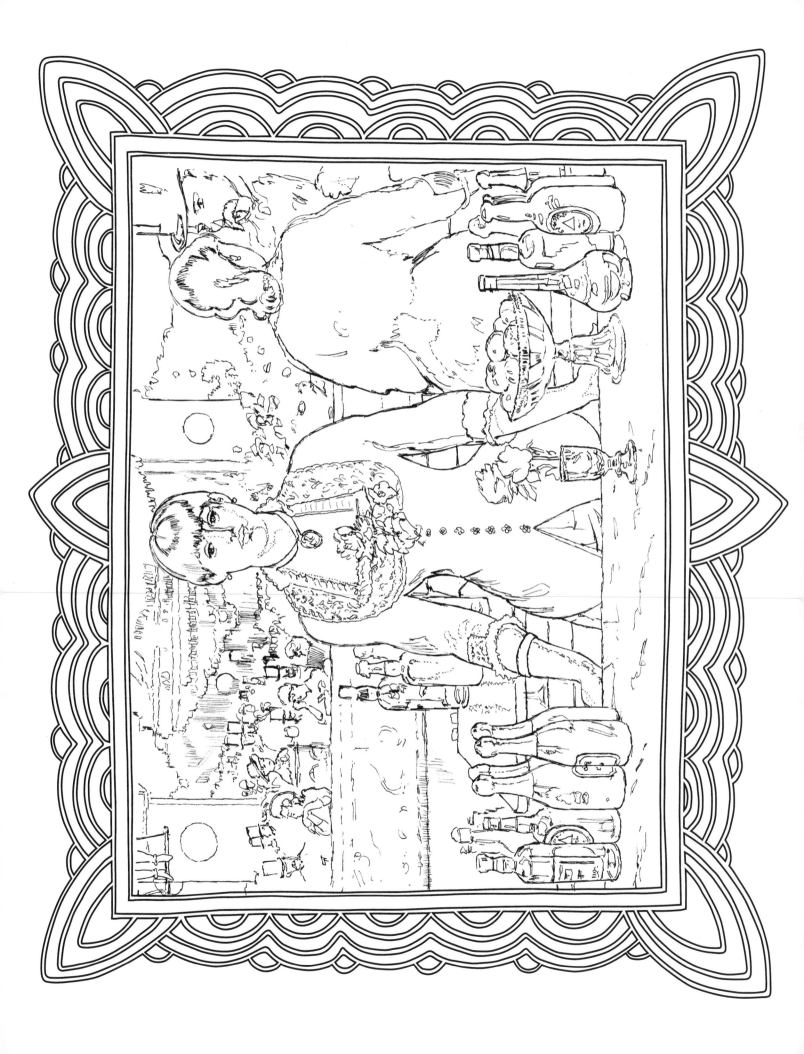

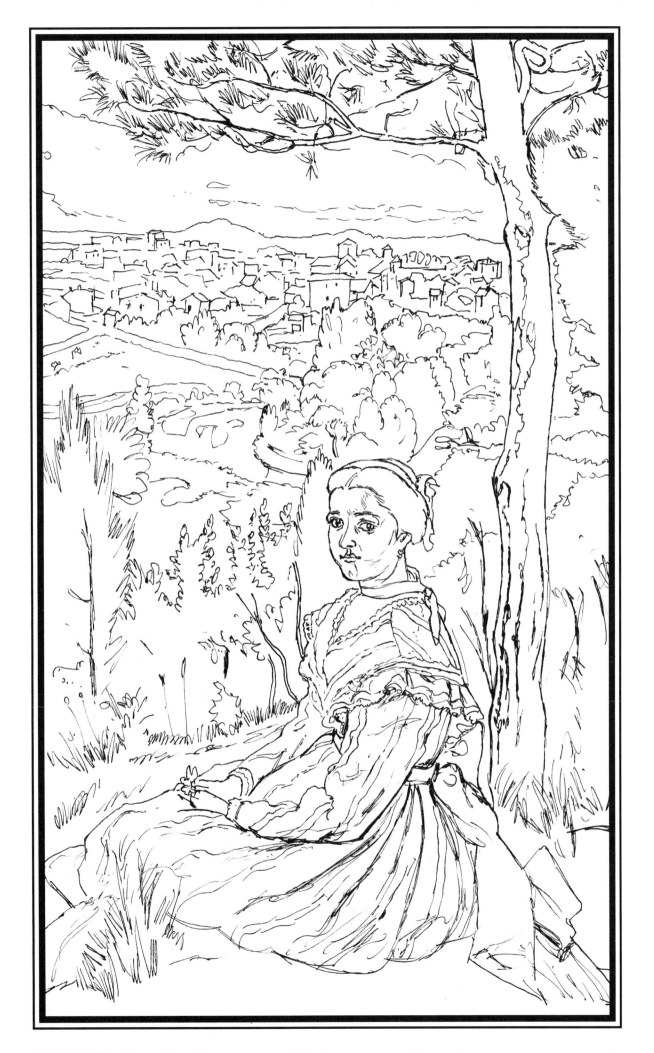

Henri de Toulouse-Lautrec
Au Moulin Rouge
1892

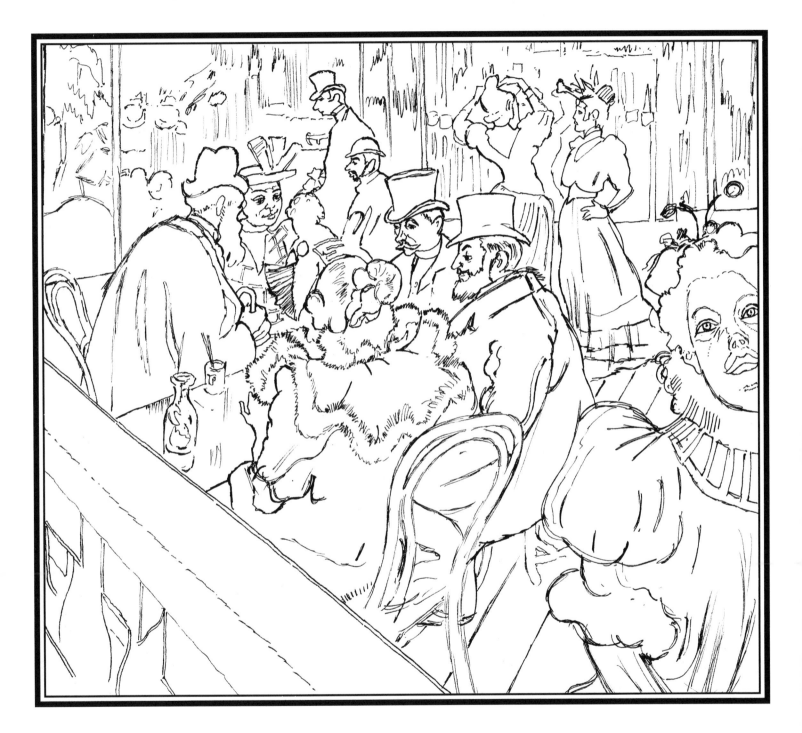

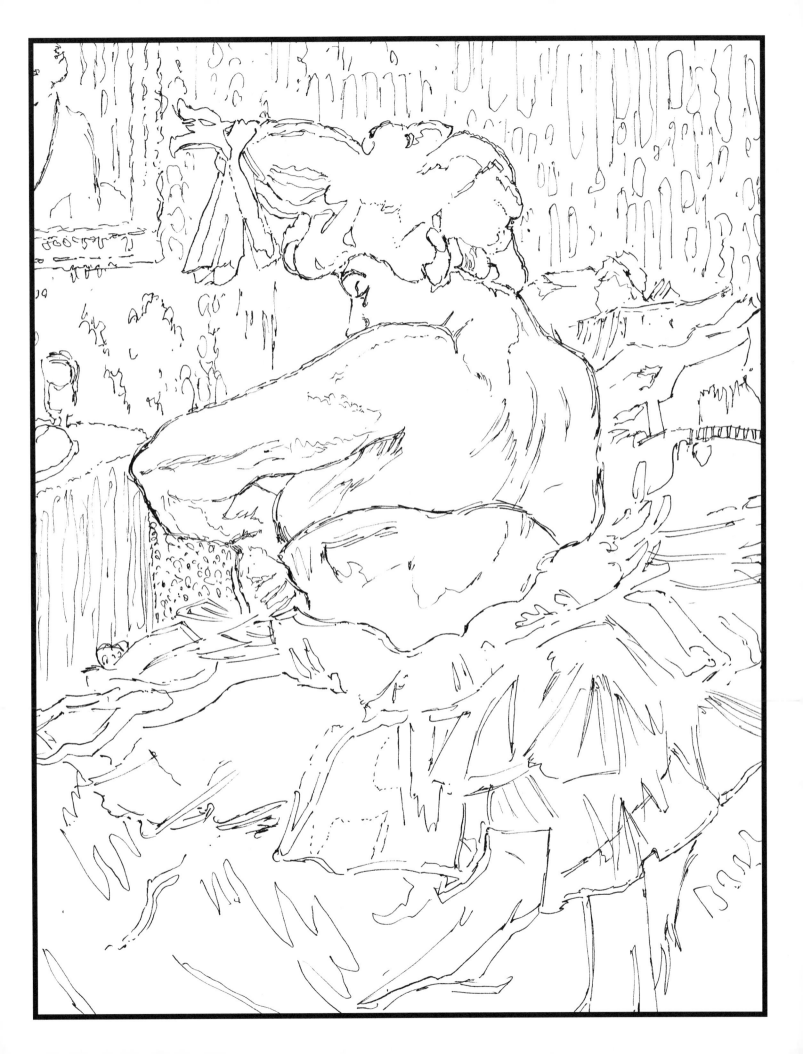

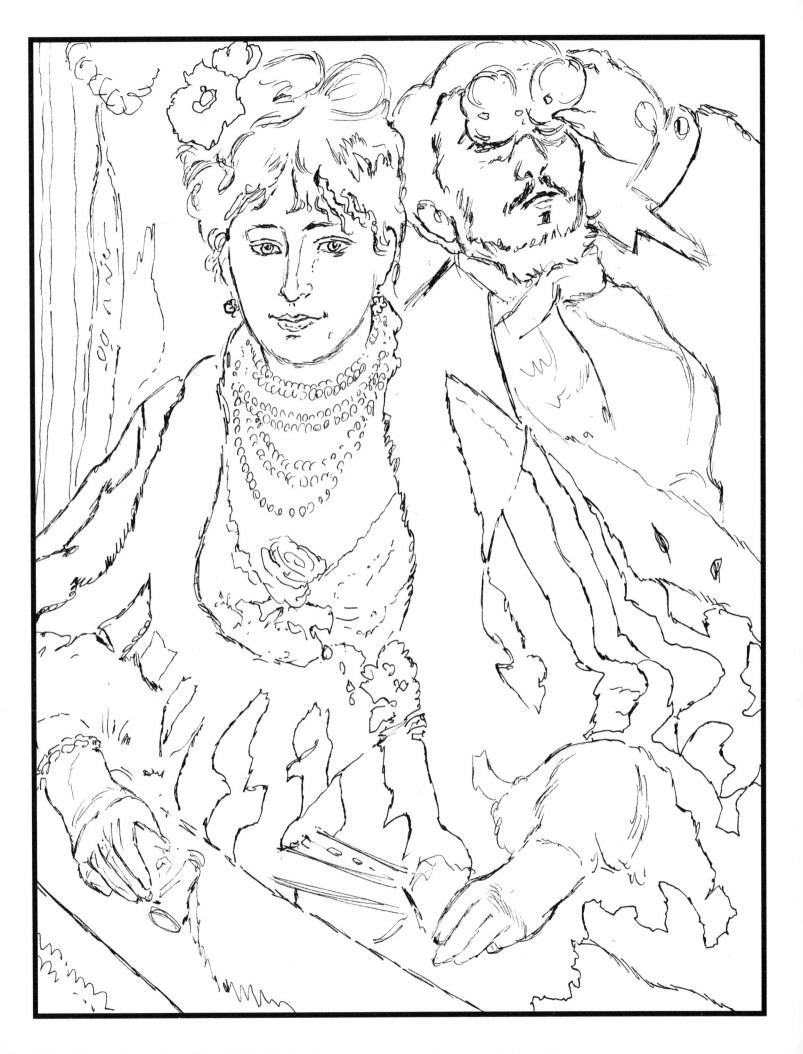

Mary Cassatt
Five O'Clock Tea
1880

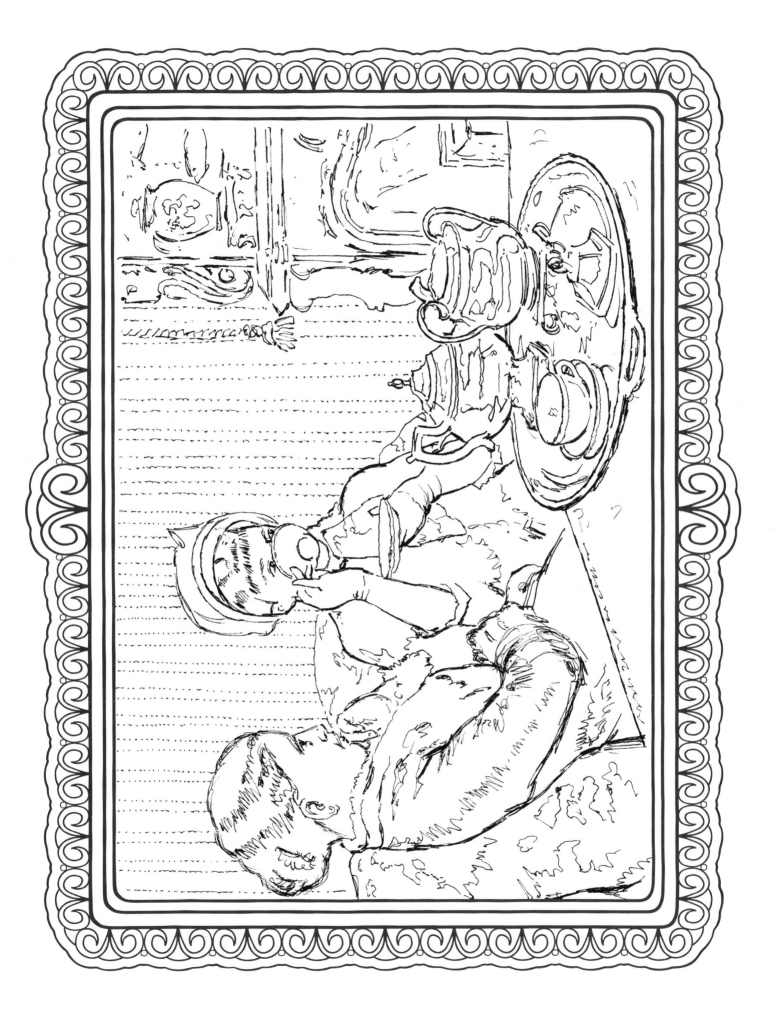

Paul Cézanne
L'Estaque, vue du golfe de Marseille
1886-90

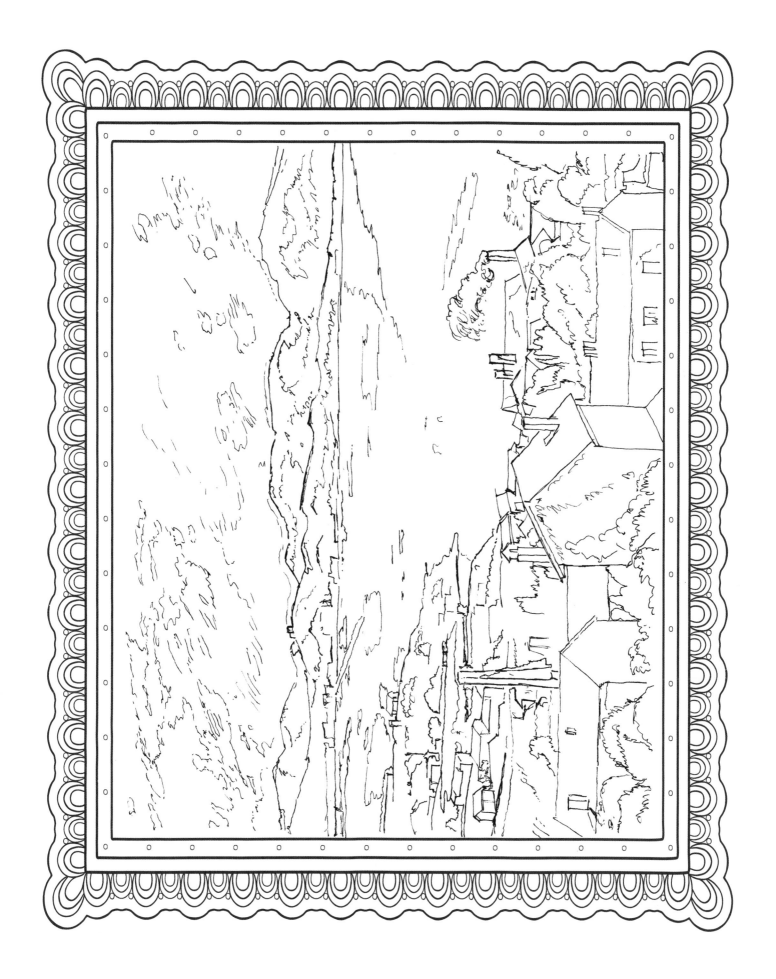

Paul Cézanne
Nature morte au plateau de fruits
1879-82

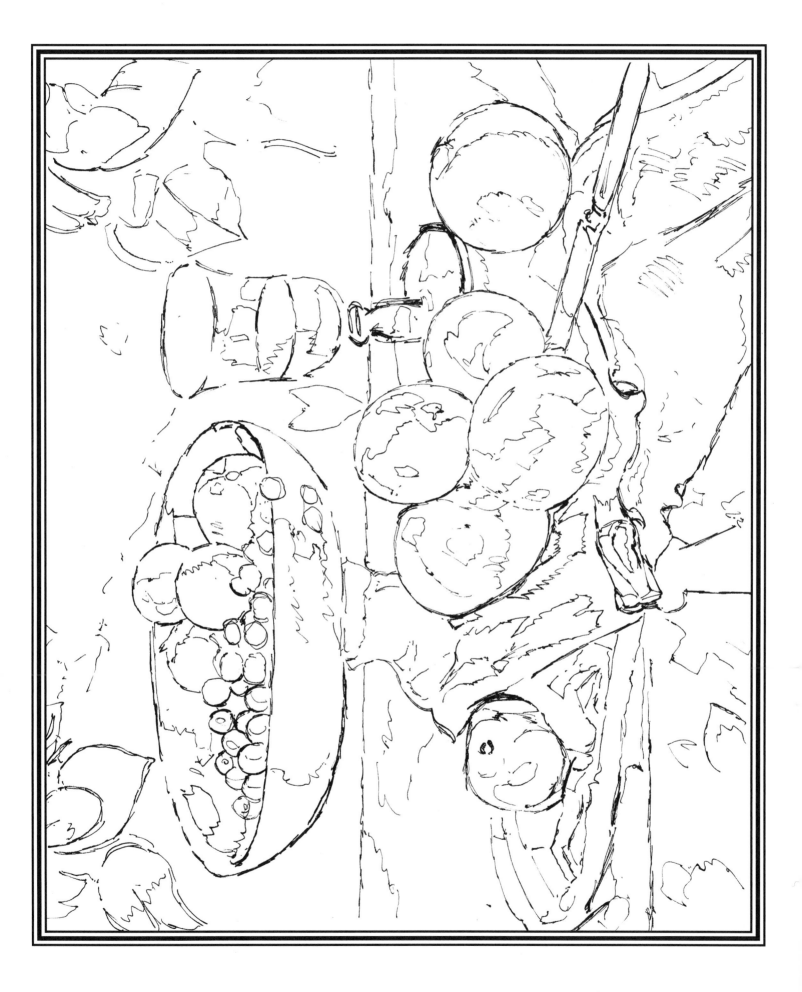

Paul Cézanne
Femme à la cafetière
1890-94

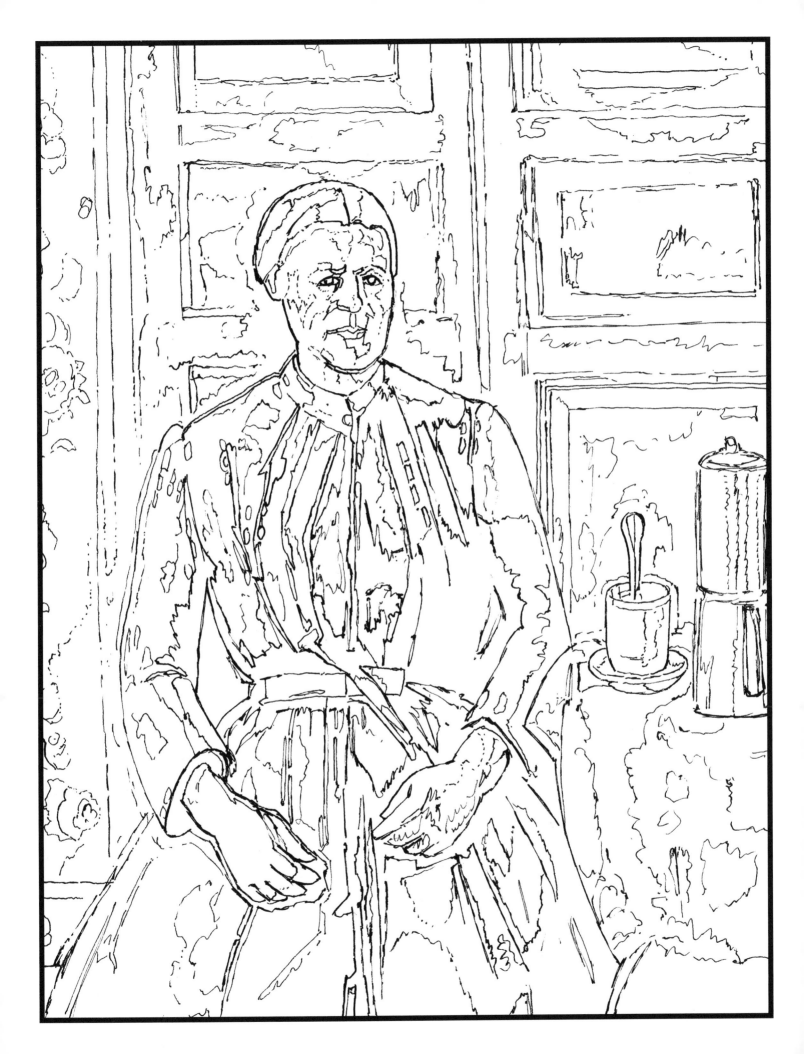

Edgar Degas
L'absinthe
1876

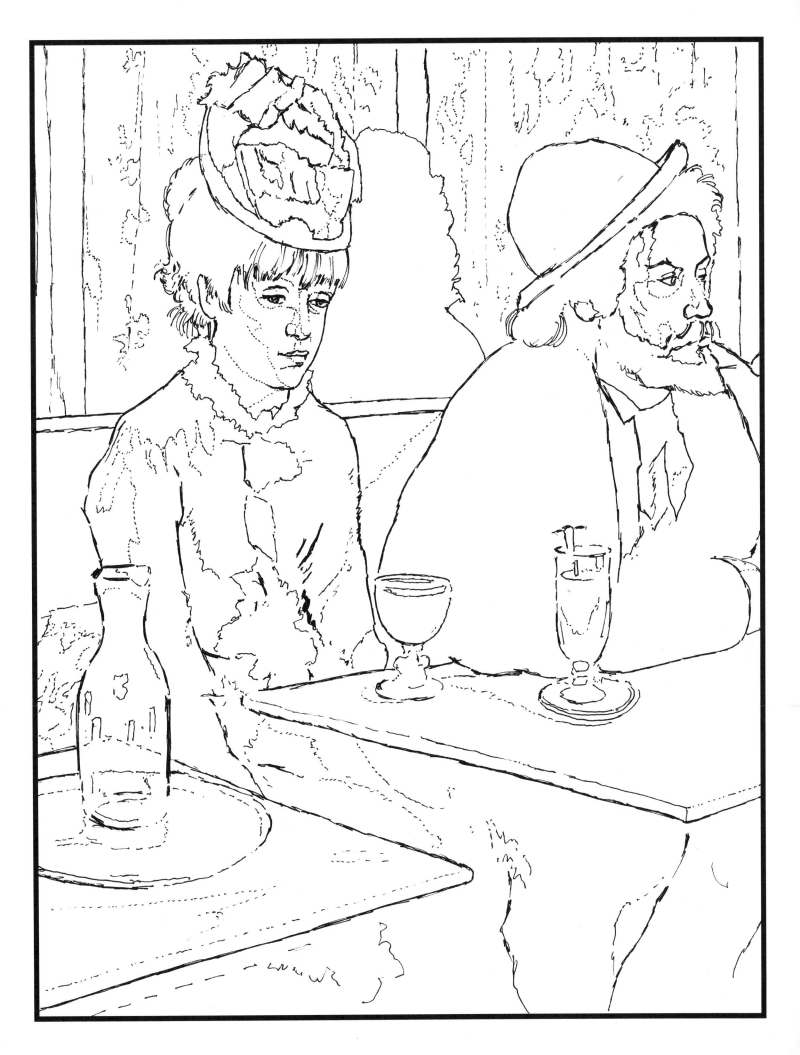

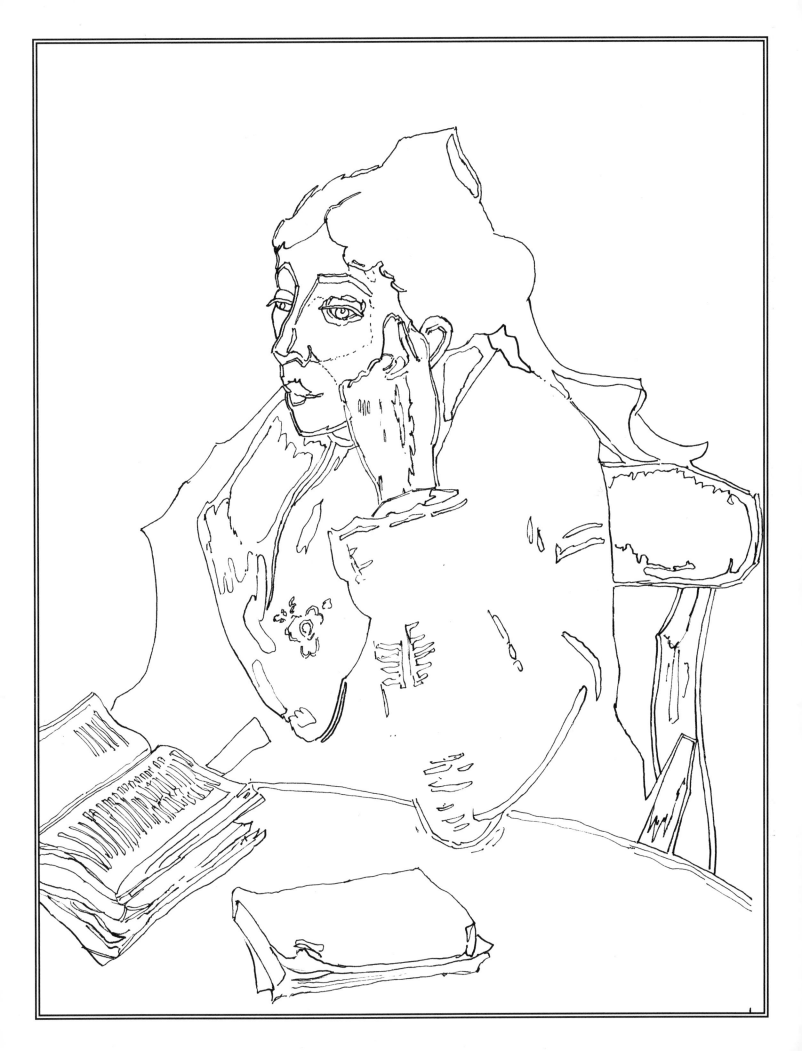

Vincent van Gogh
Les tournesols
1888

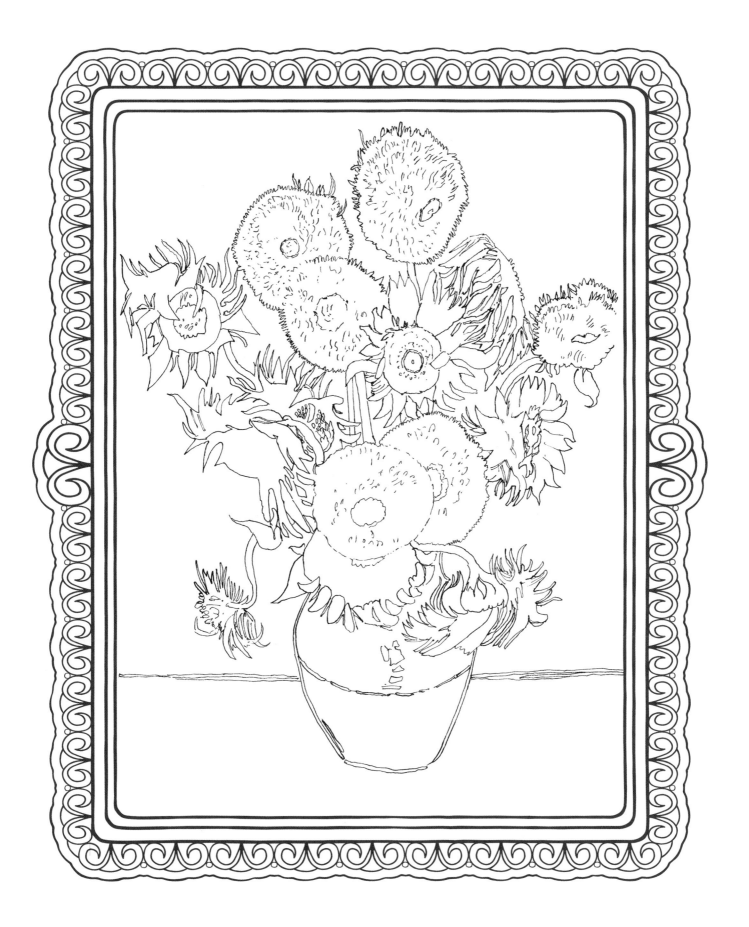

Vincent van Gogh
La chaise de Vincent avec sa pipe
1888-89

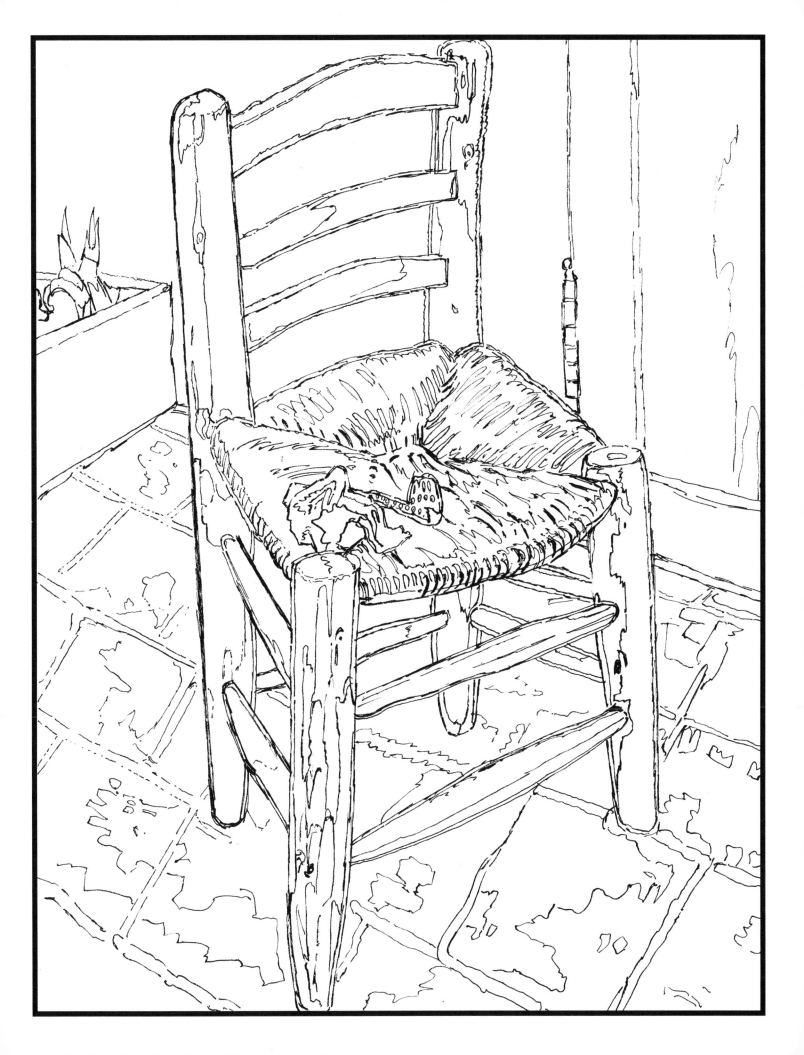

Pierre-Auguste Renoir
La natte (Suzanne Valadon)
1885

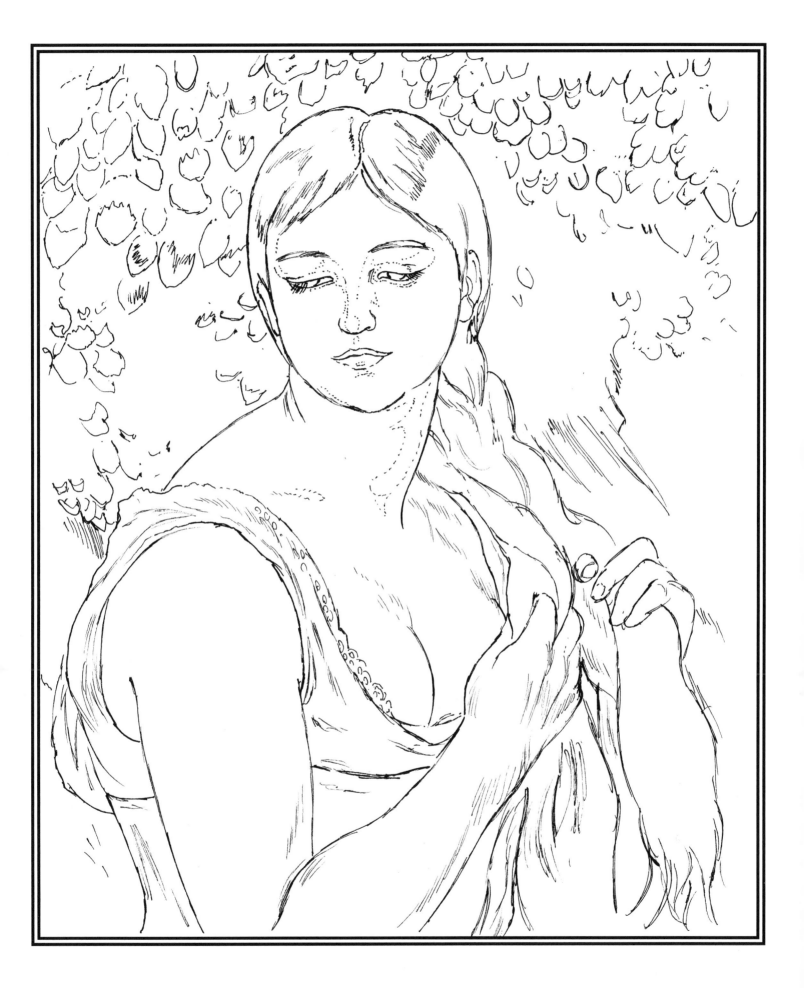

Pierre-Auguste Renoir
Portrait de Mademoiselle Irène Cahen d'Anvers
1880

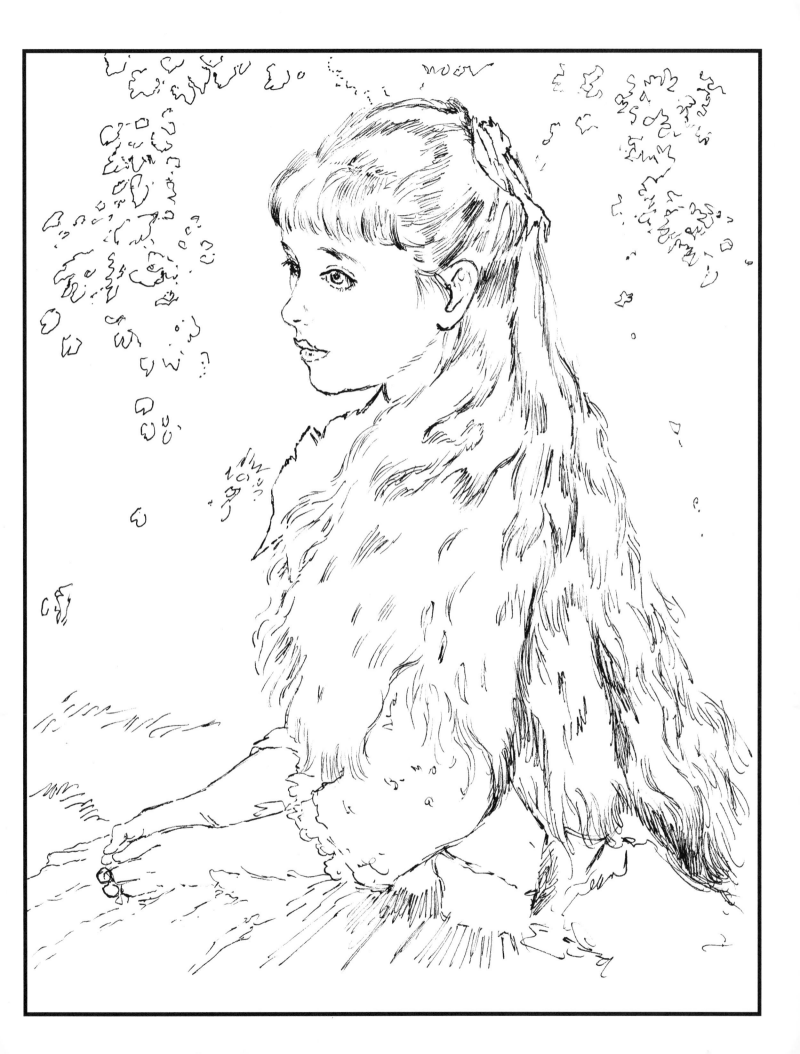

Pierre-Auguste Renoir
Acrobates au cirque Fernando (Francisca et
Angelina Wartenberg)
1879

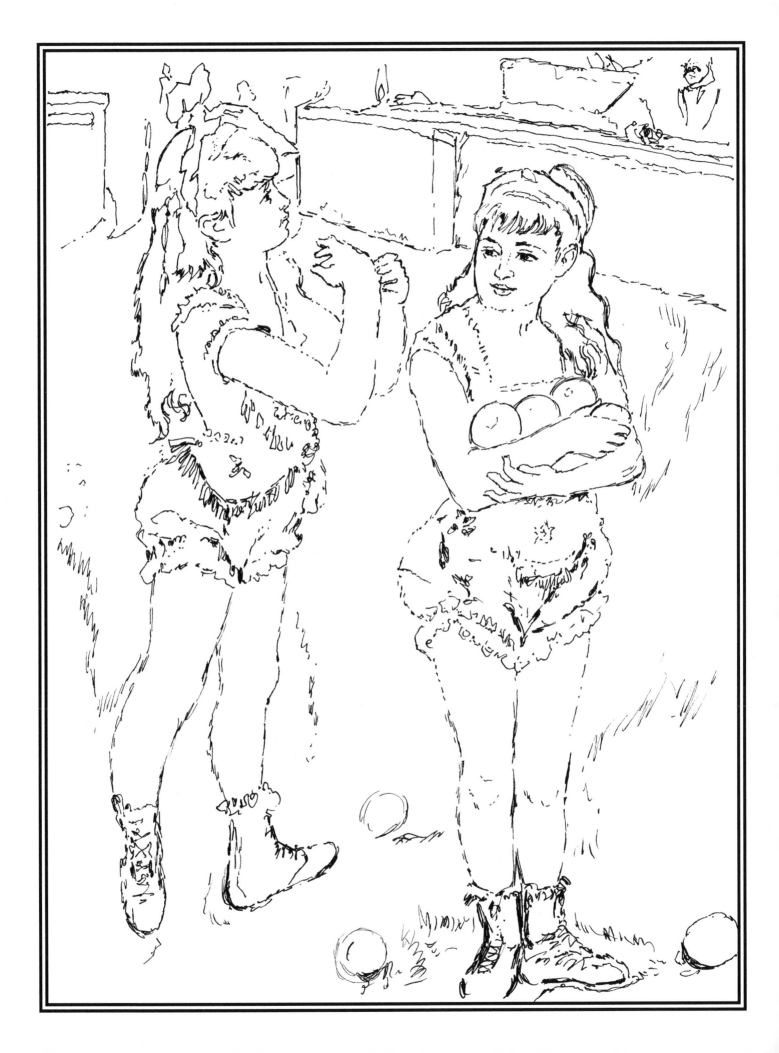

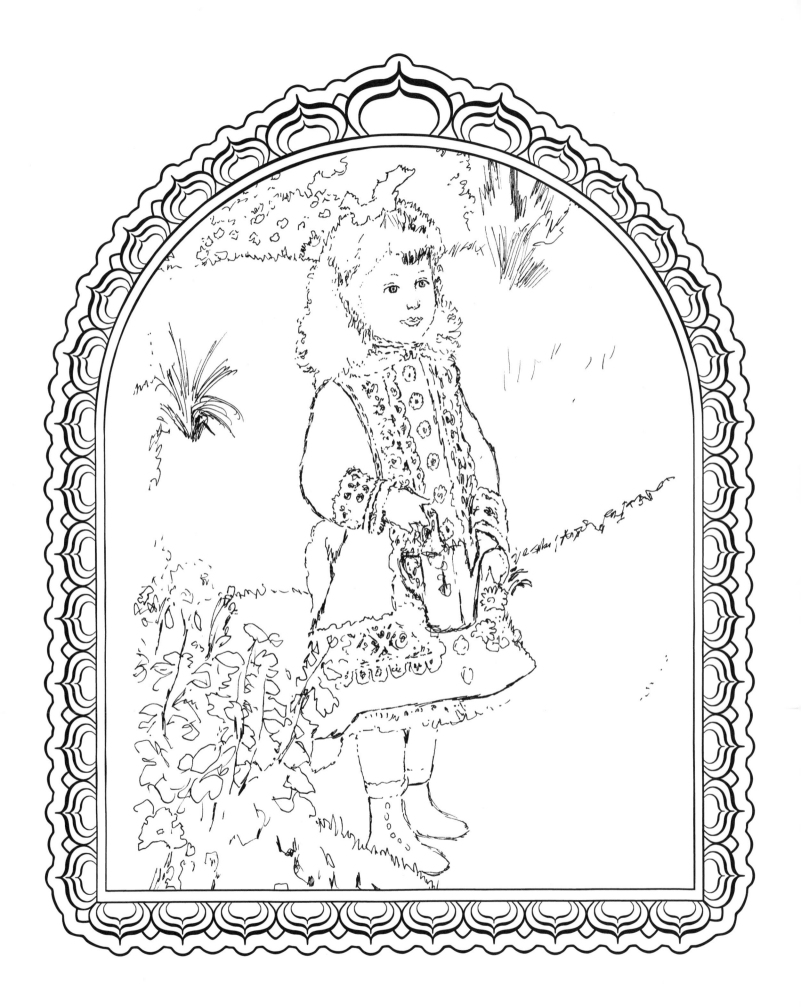

Pierre-Auguste Renoir
Les fiancés - le ménage Sisley
1868

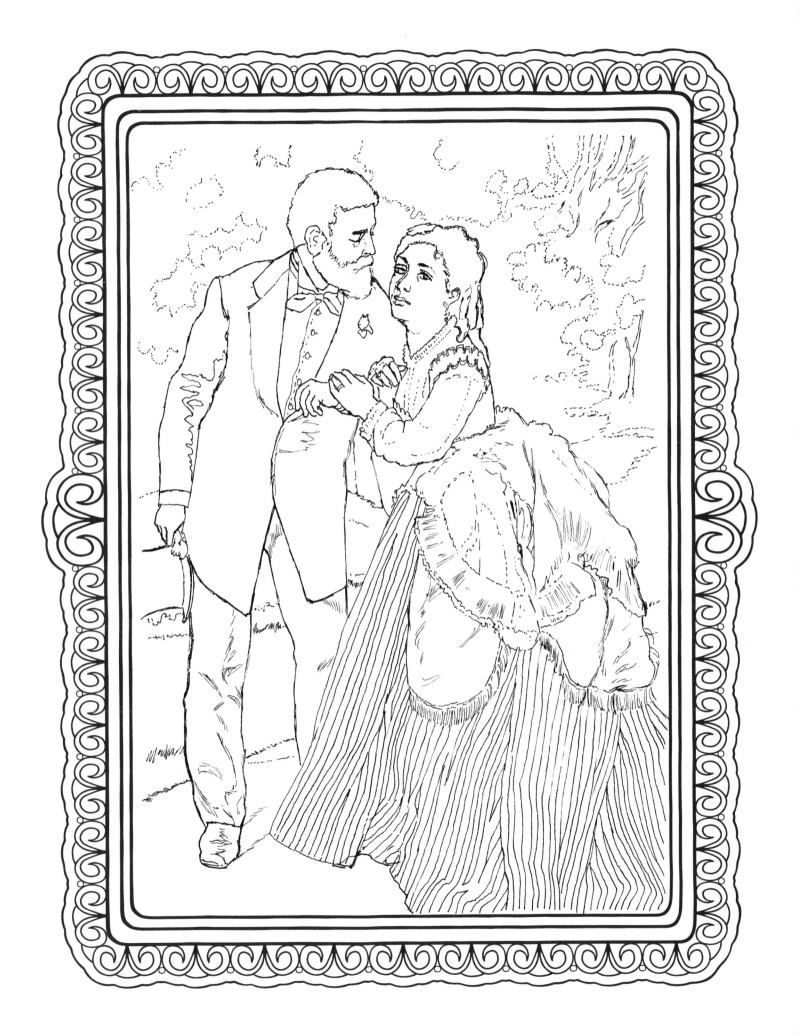

Pierre-Auguste Renoir
Femme assise au bord de la mer
1883

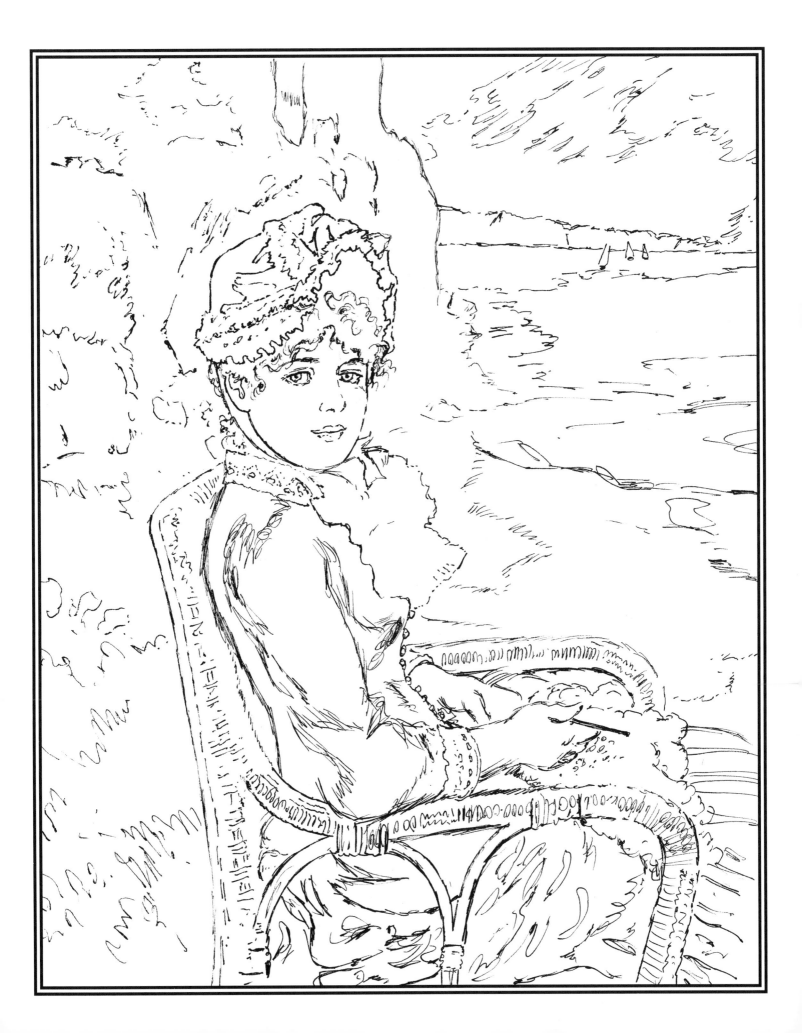

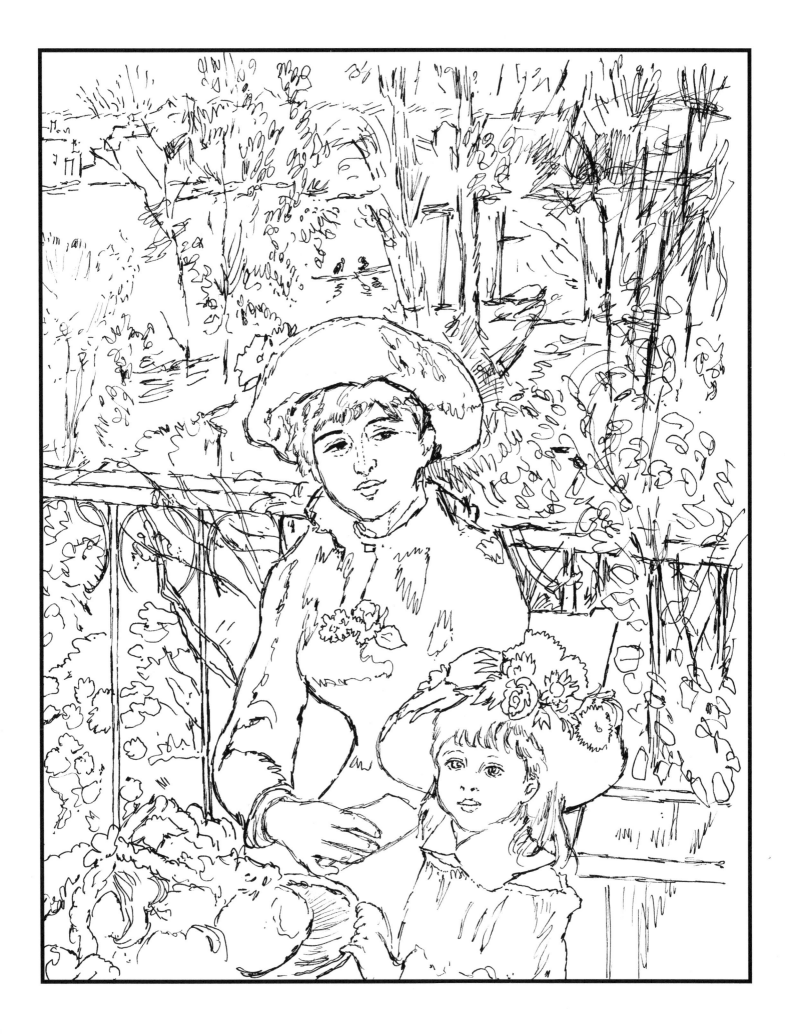

Pierre-Auguste Renoir
Madame Georges Charpentier et ses enfants
1878

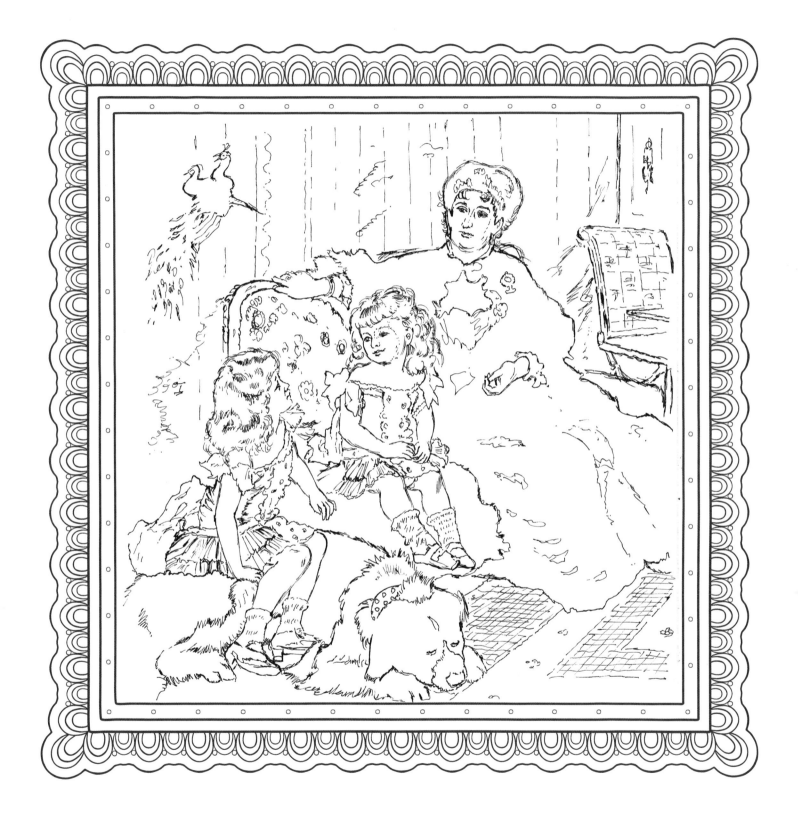

Pierre-Auguste Renoir
Lise (femme à l'ombrelle)
1867

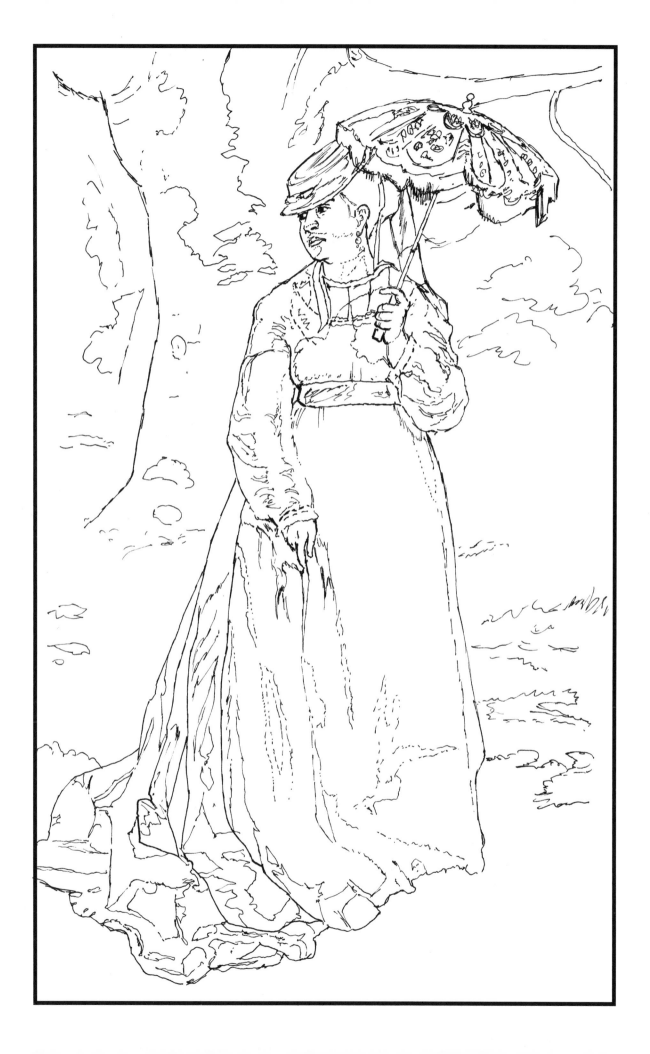

Henri de Toulouse-Lautrec
A la Mie
1891

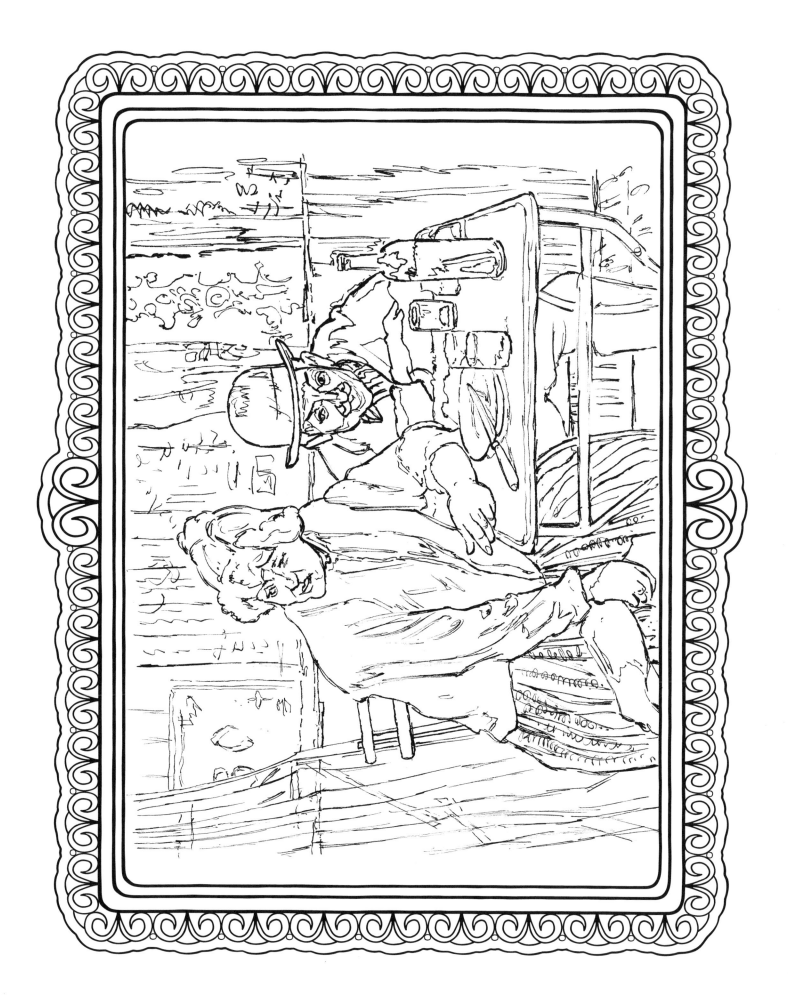

Henri de Toulouse-Lautrec
Bal au Moulin Rouge
1890

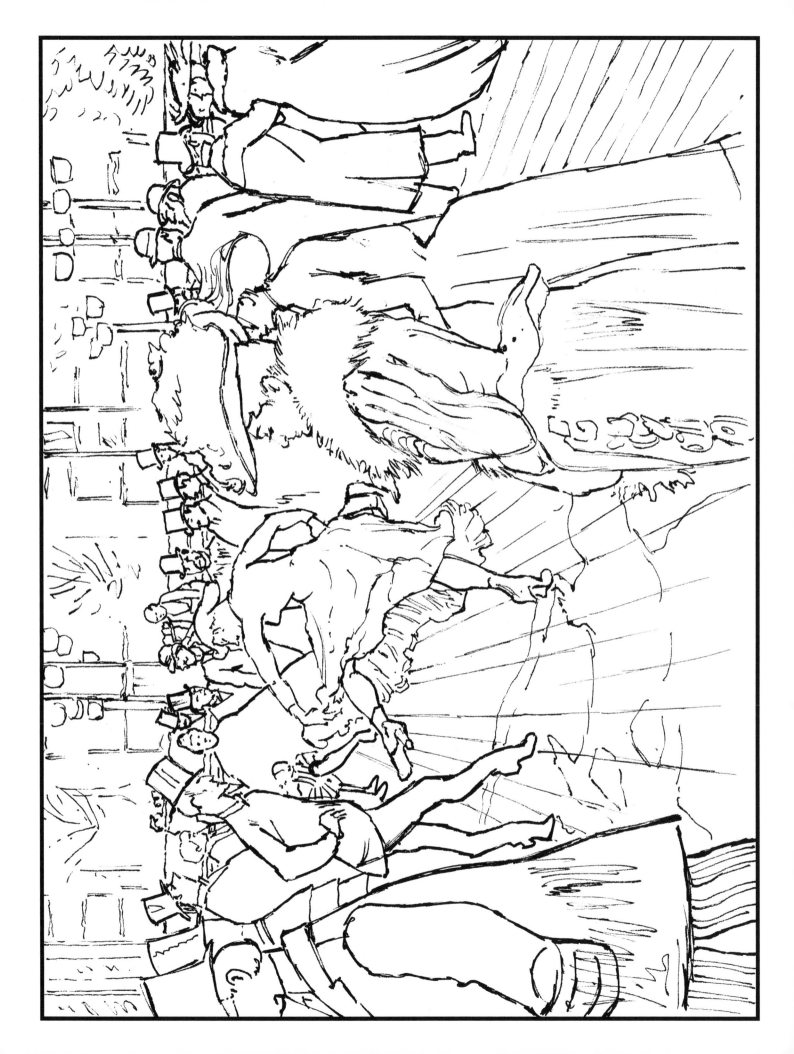

Henri de Toulouse-Lautrec
L'Anglaise de l'Etoile chez le Havre
1899

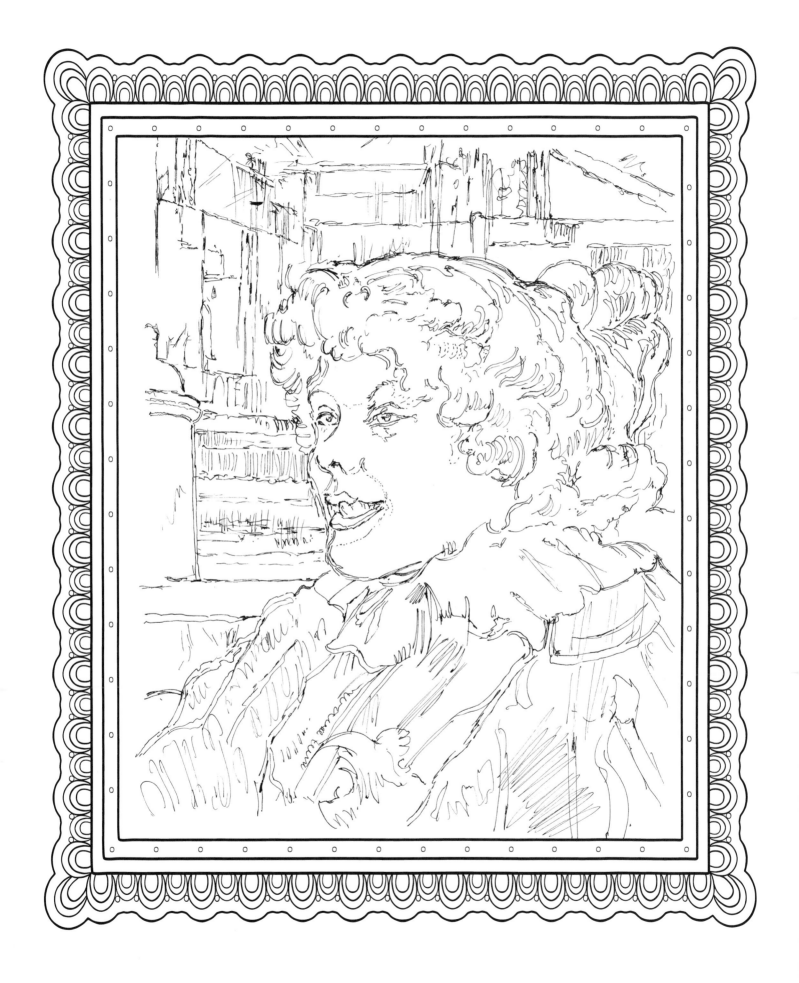

Henri de Toulouse-Lautrec
La clownesse Cha-u-Kao
1895

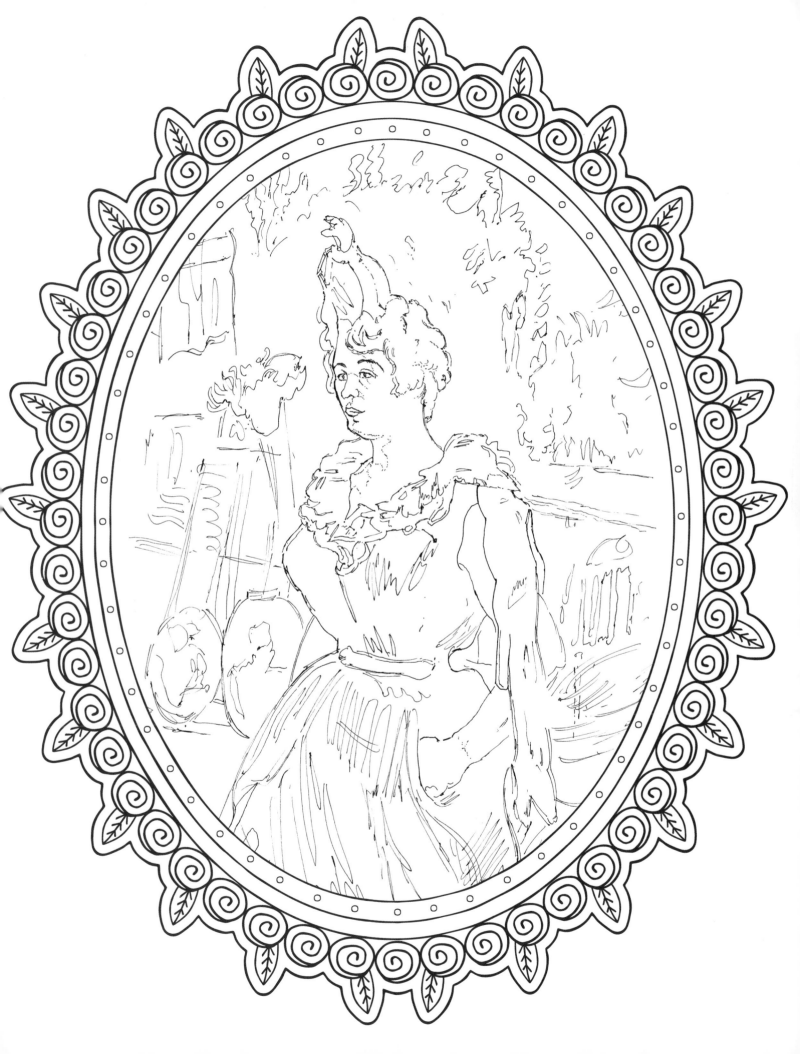

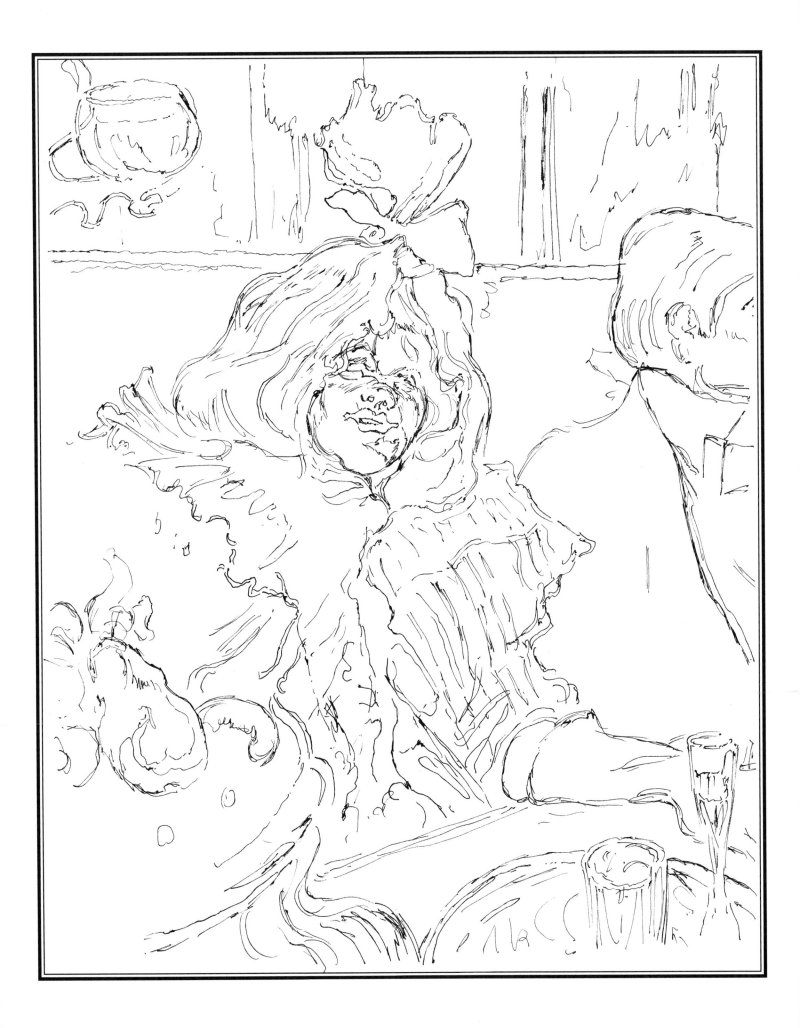

Henri de Toulouse-Lautrec
Marcelle Lender dansant le boléro dans
'Chilpéric'
1895

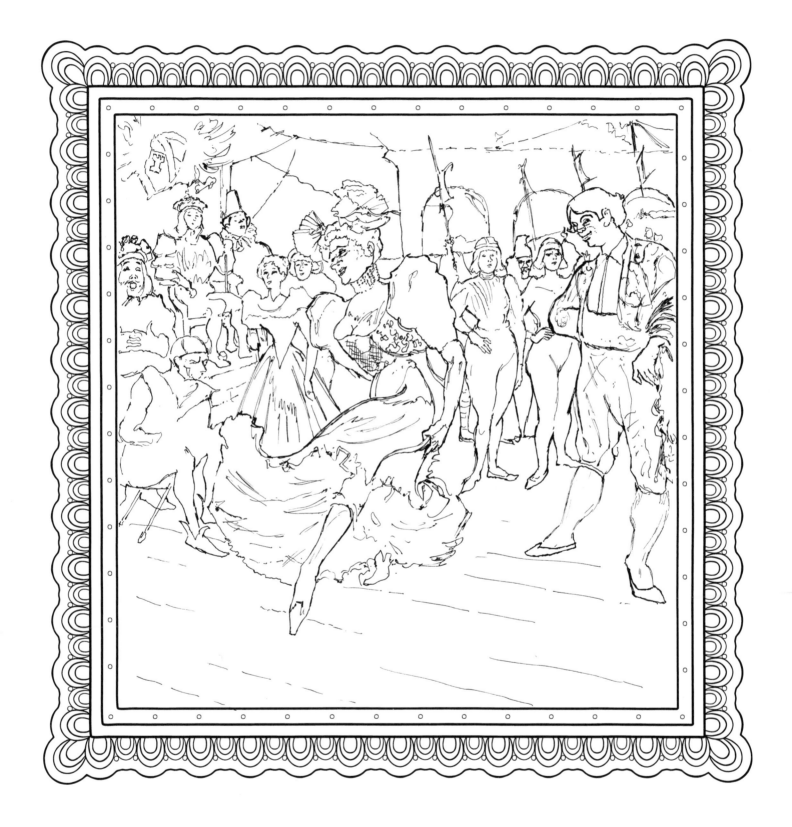

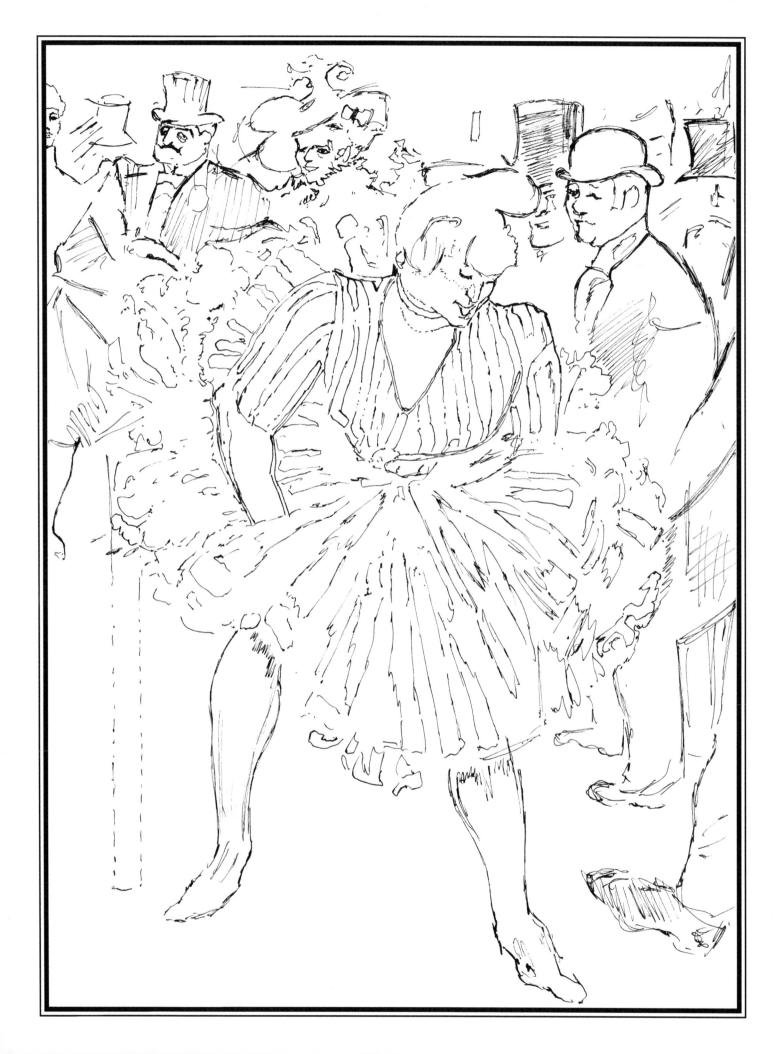

Henri de Toulouse-Lautrec
Deux femmes dansant au Moulin Rouge
1892

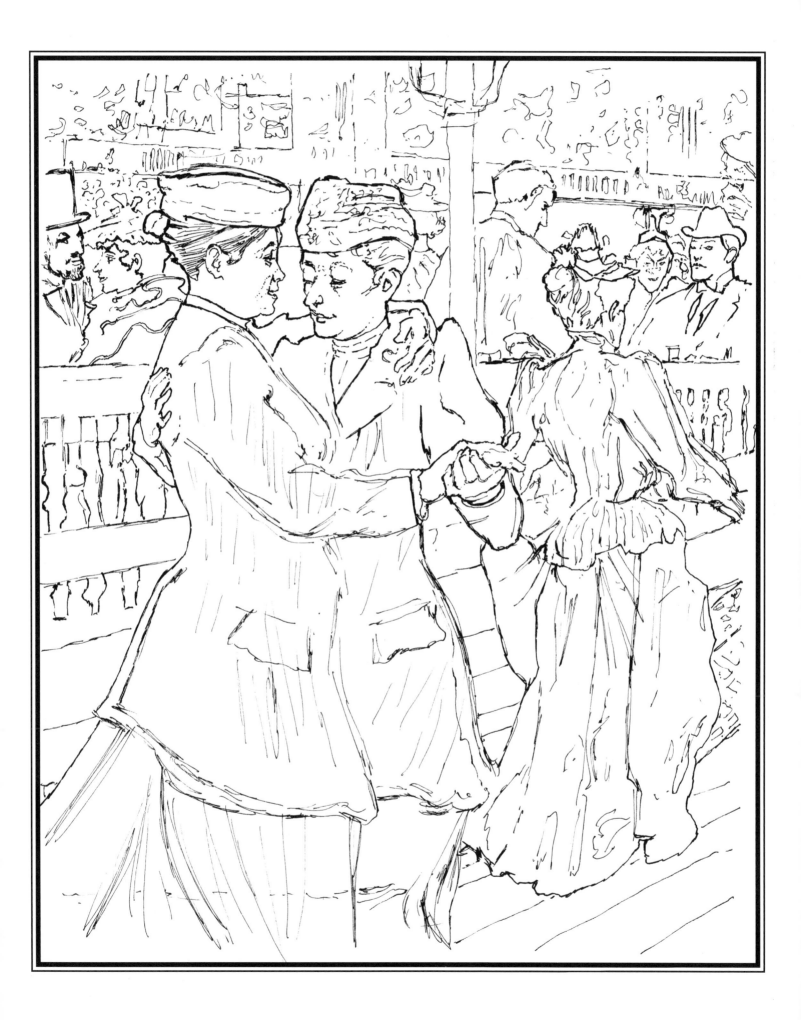

Claude Monet
Terrasse à Sainte Adresse
1867

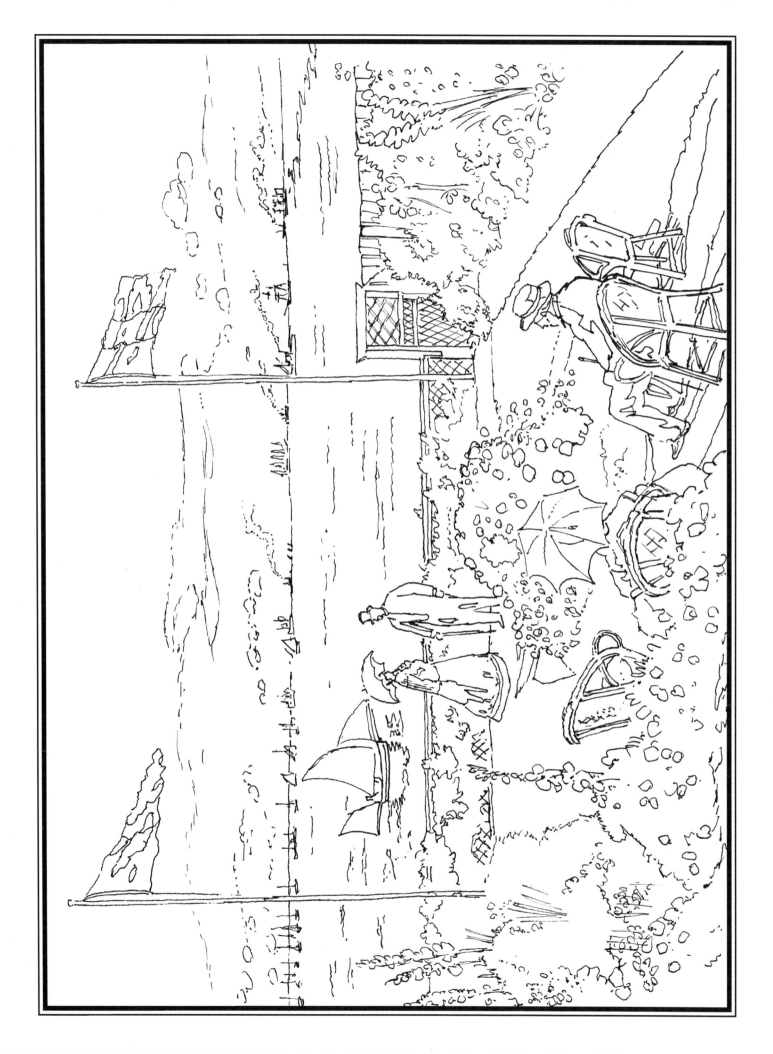

Claude Monet
Les falaises d'Étretat
1885

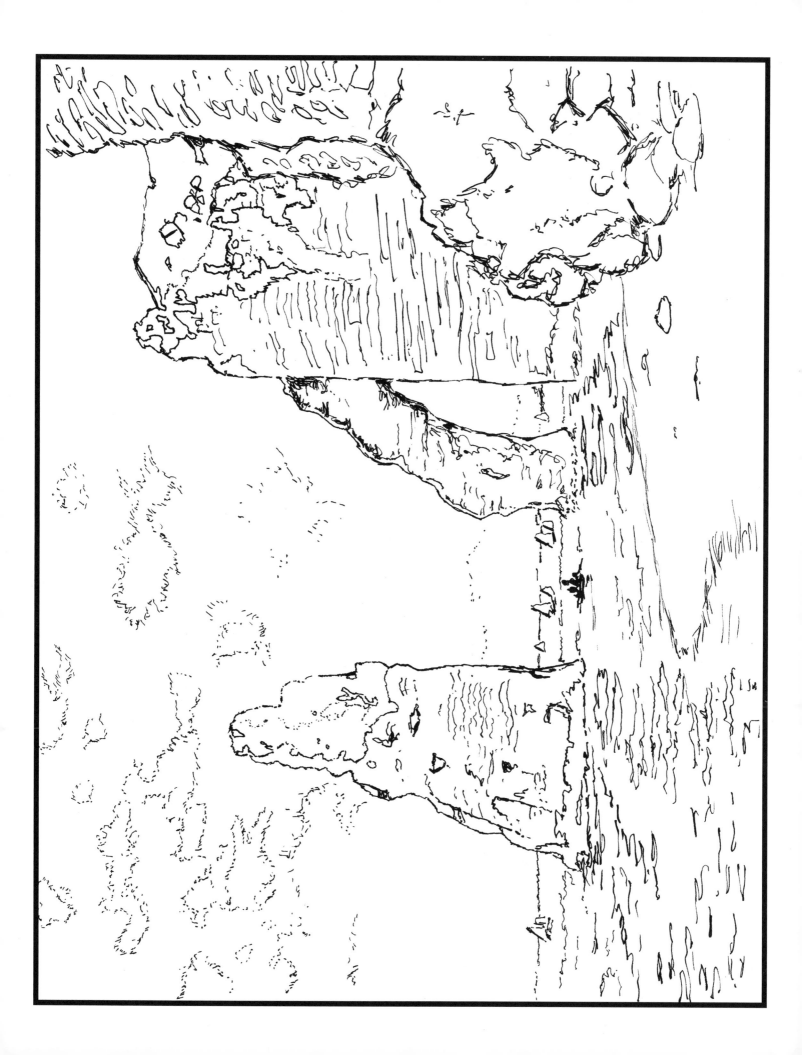

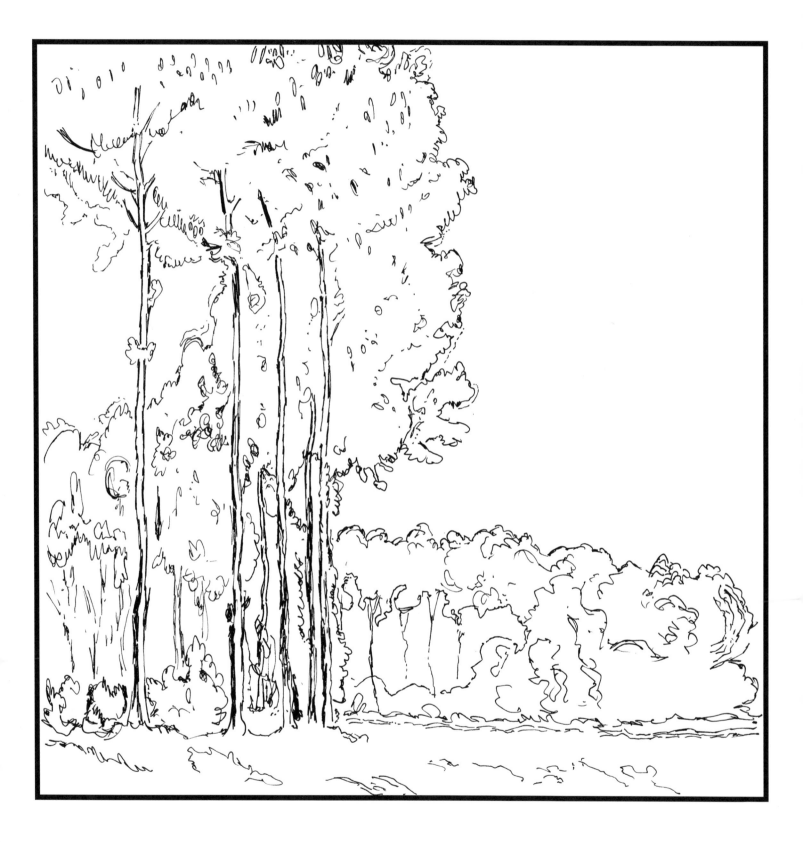

Claude Monet
Meules à la fin de l'été, effet du matin
1891

Mary Cassatt
Children at the Seashore
1885

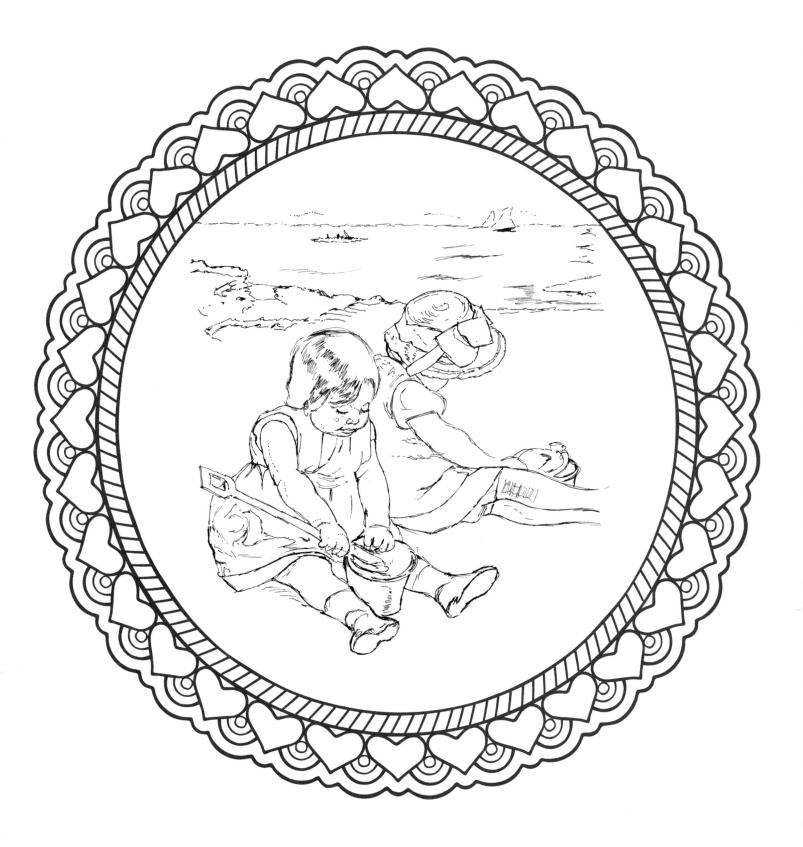

Claude Monet
Hôtel des Roches Noires, Trouville
1880

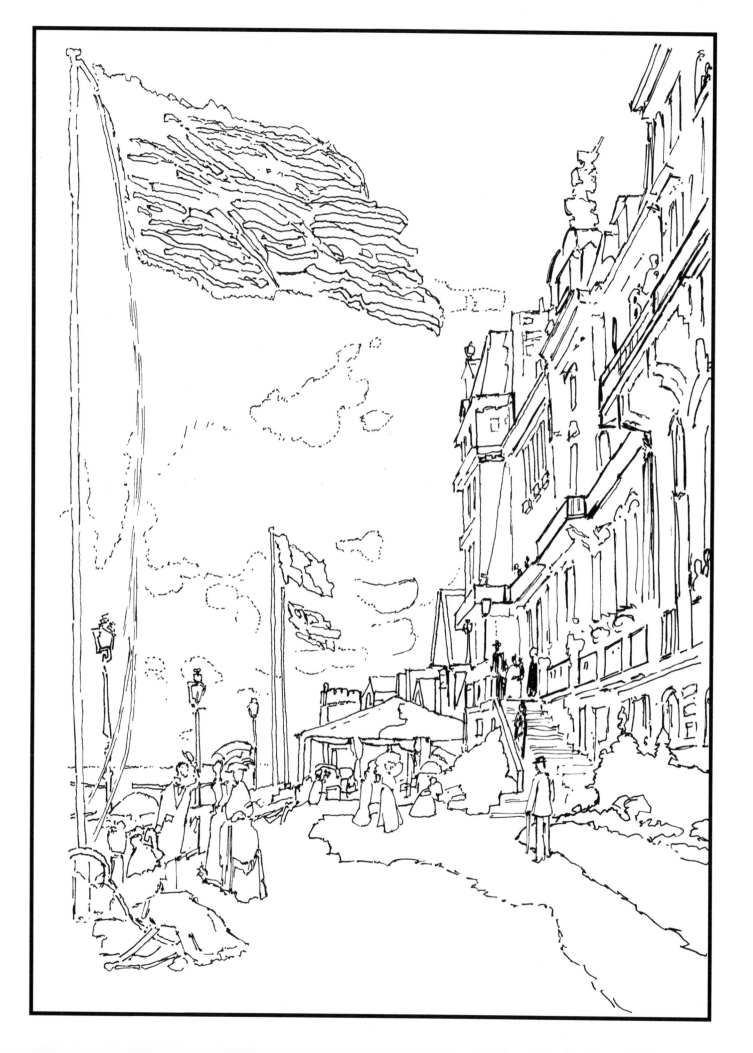

Claude Monet
La grenouillère
1869

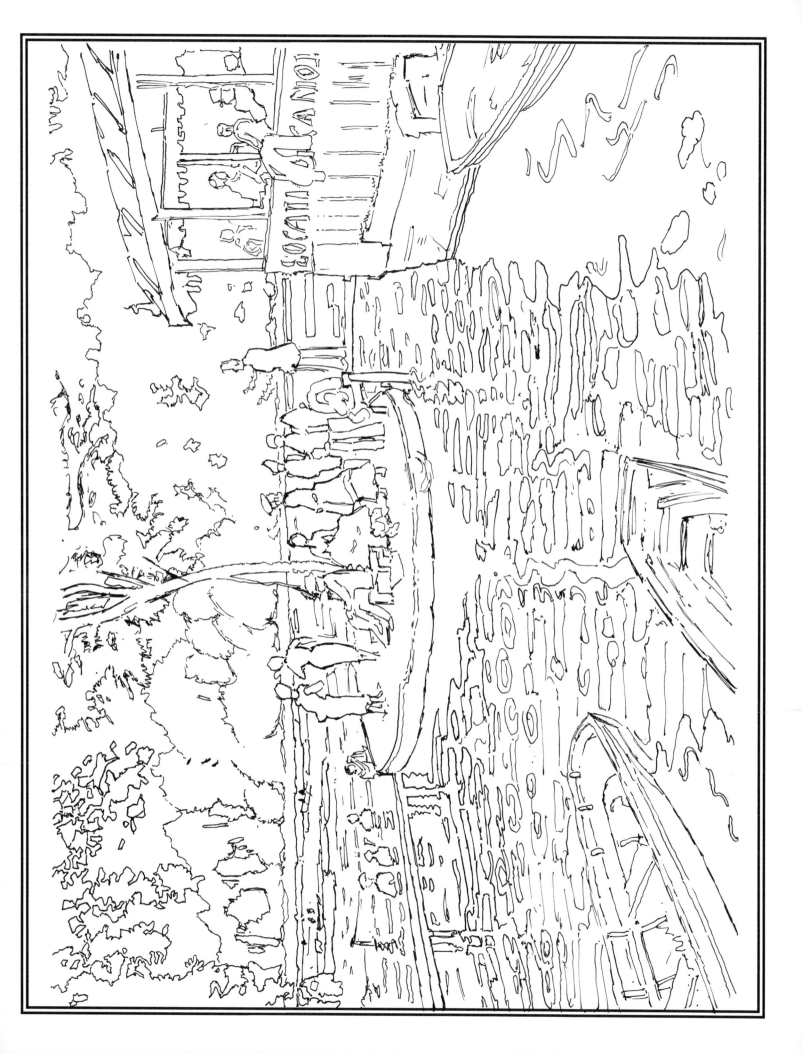

Camille Pissarro
Lordship Lane Station
1873

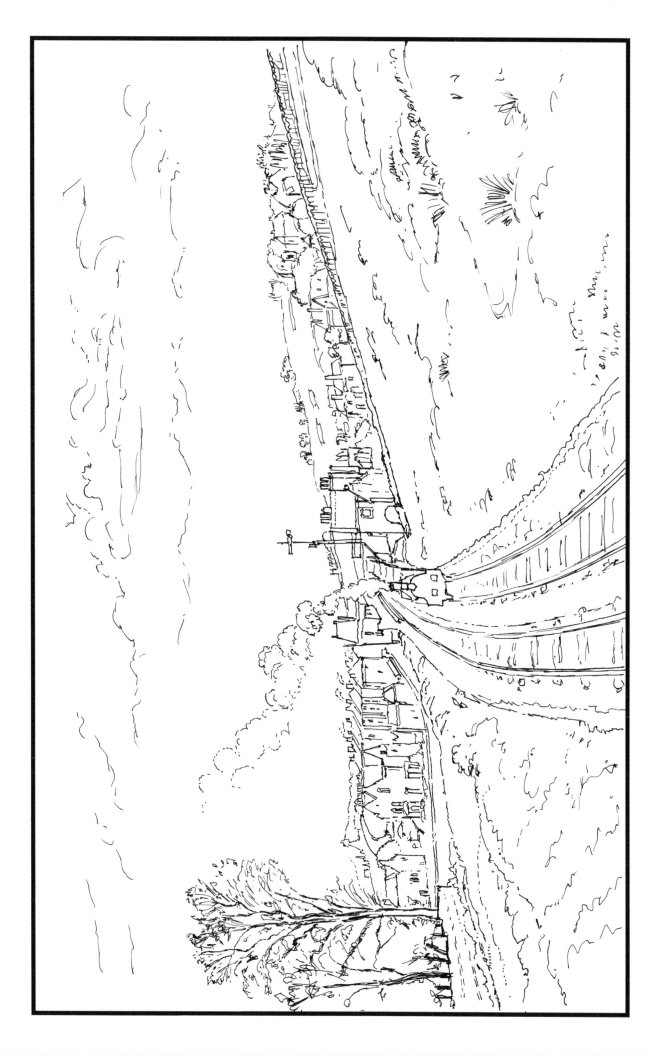

Camille Pissarro
Entrée du village de Voisins
1872

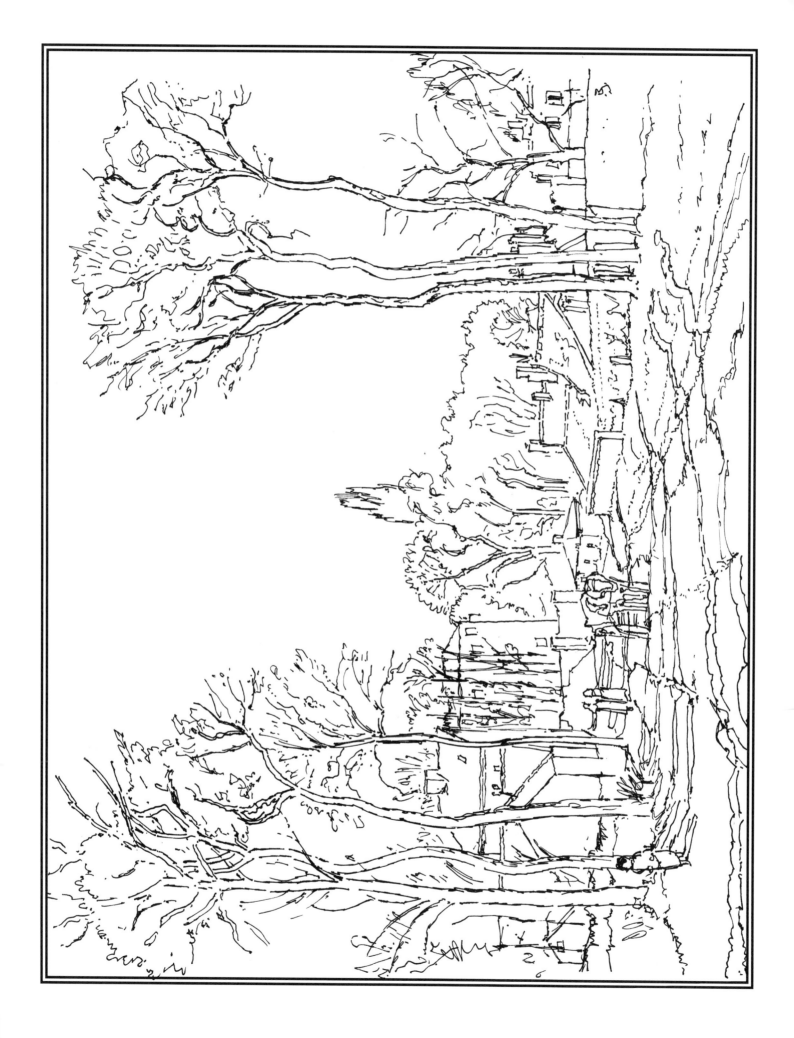

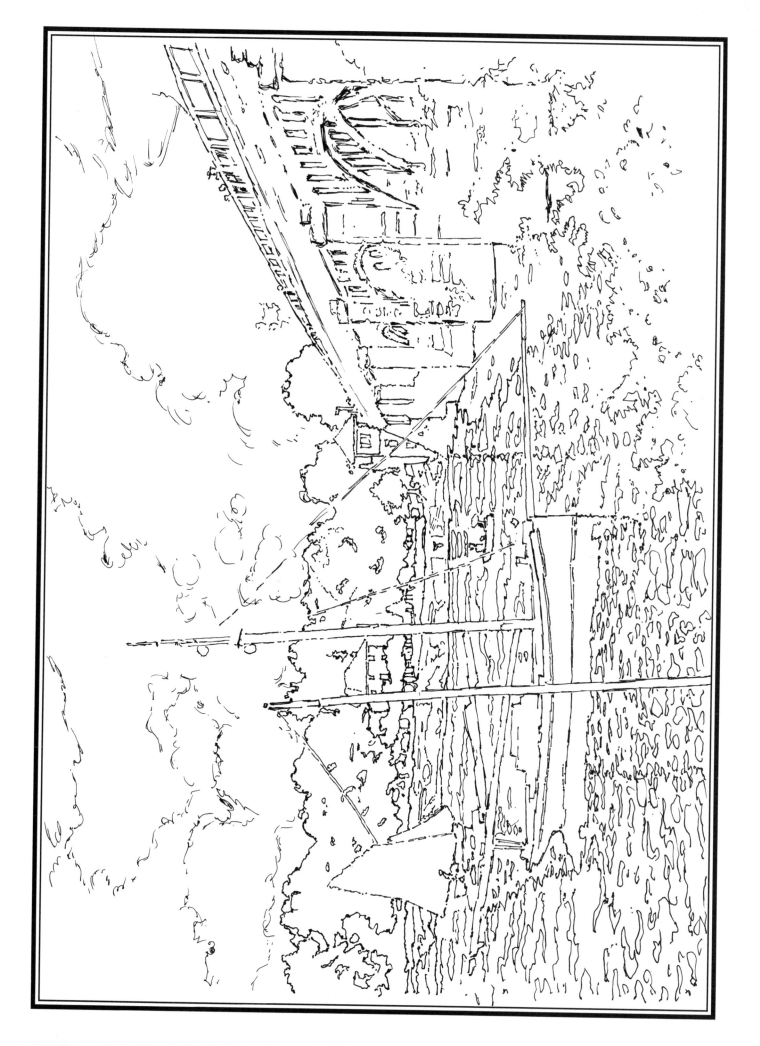

Alfred Sisley
Louveciennes or The Heights at Marly
1873

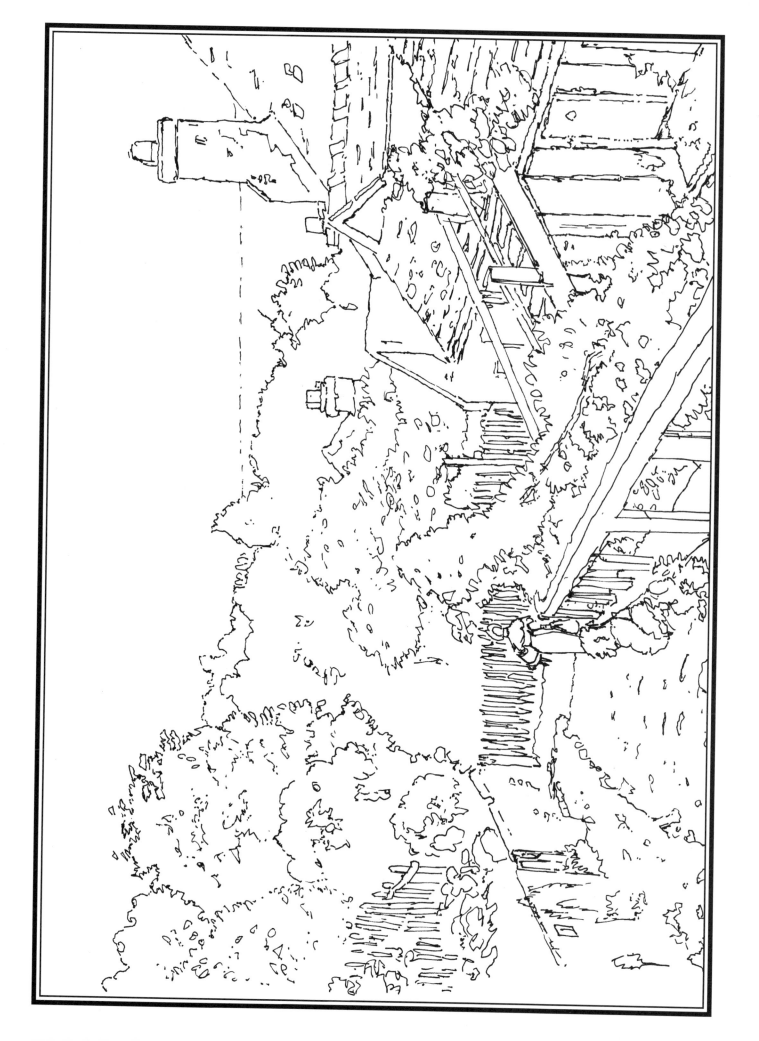

William Stott of Oldham
CMS reading by gaslight
1884

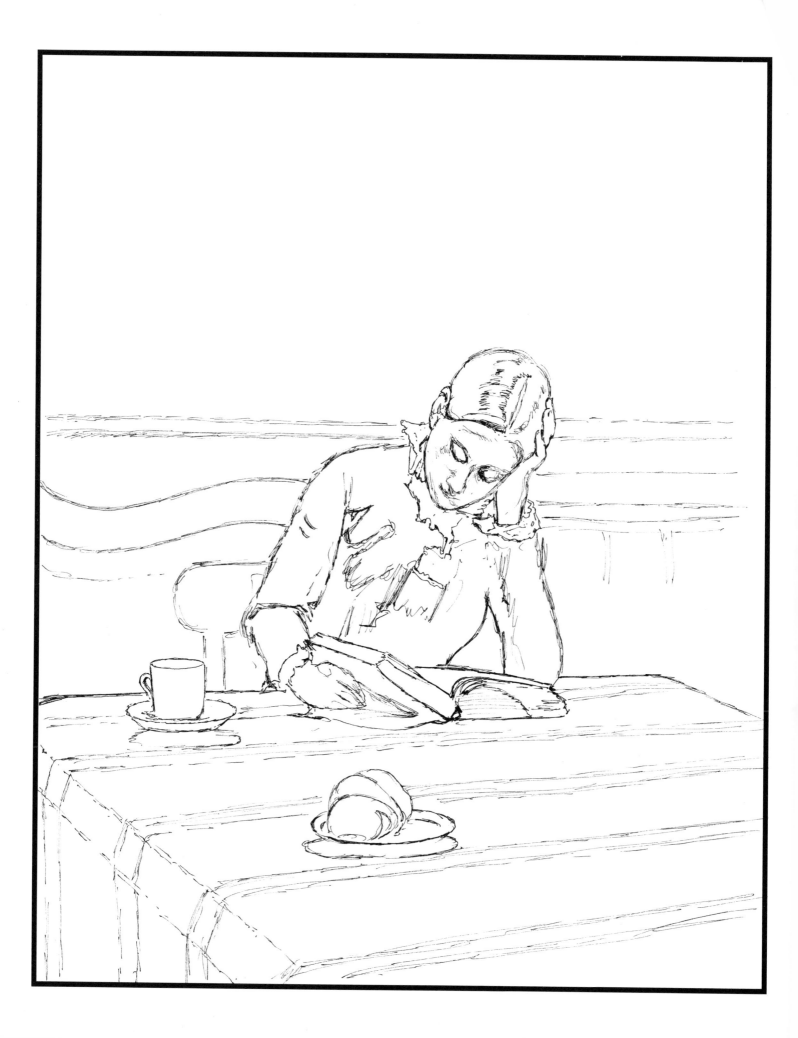

Pierre-Auguste Renoir
Danse à Bougival
1883

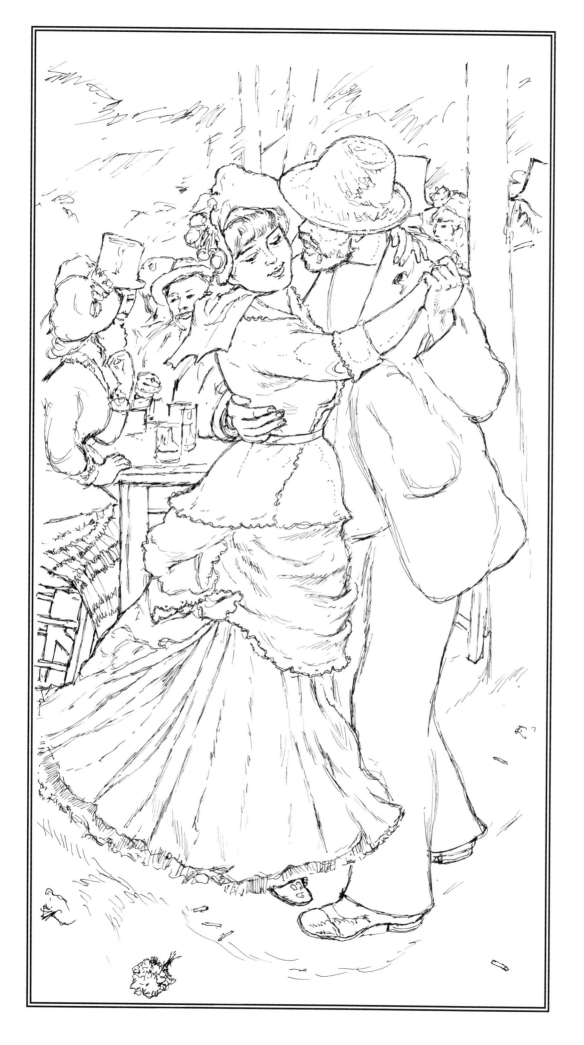

Pierre-Auguste Renoir
Danse à la ville
1883

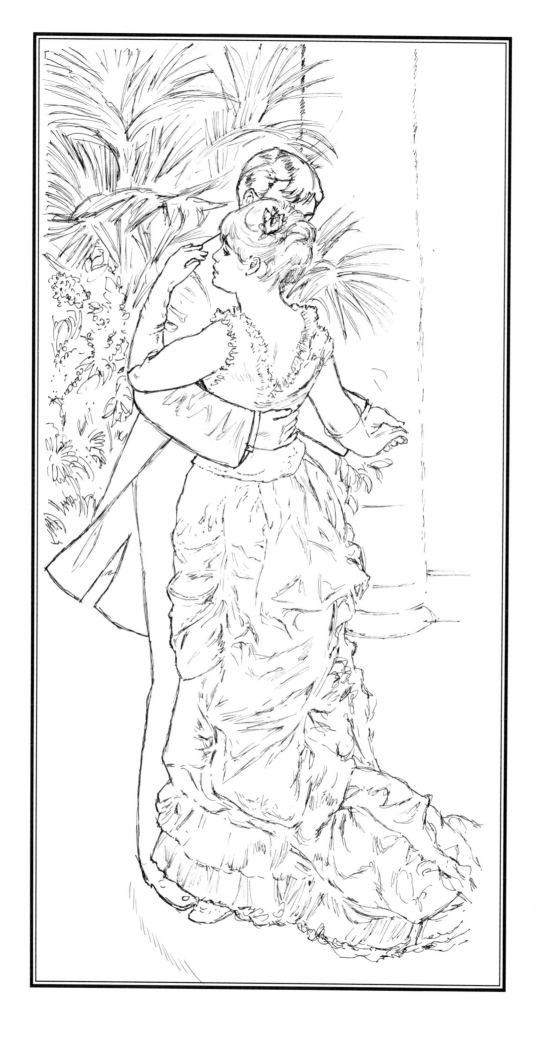

Pierre-Auguste Renoir
Danse à la campagne
1883

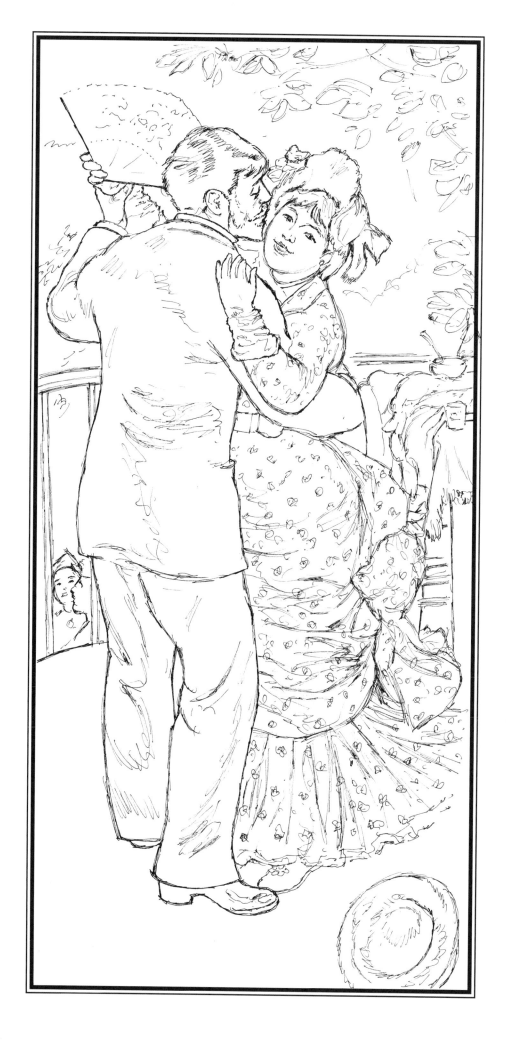